UELSMANN/YOSEMITE

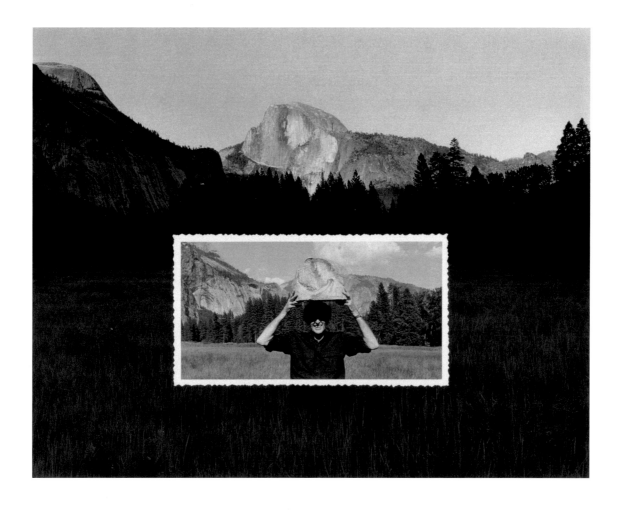

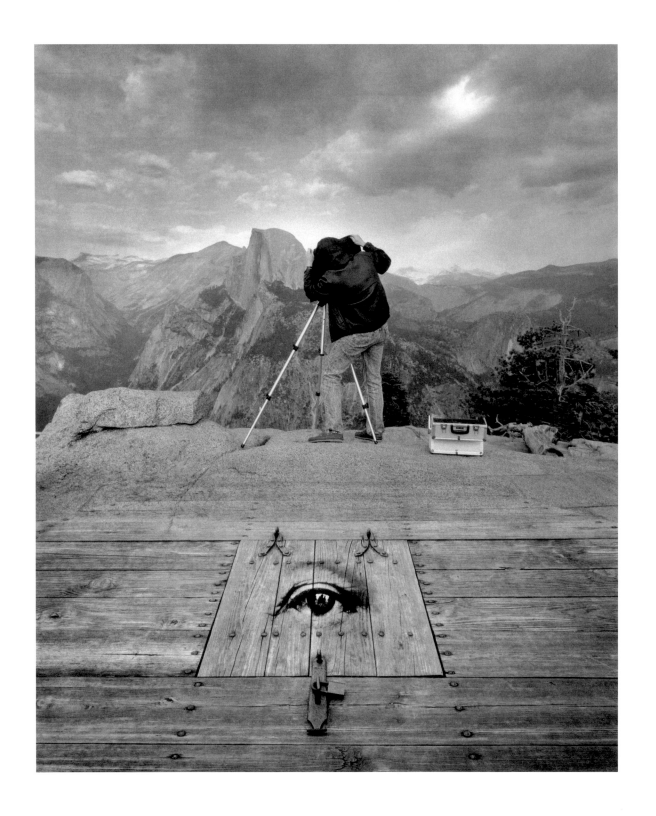

UELSMANN
YOSEMITE

PHOTOGRAPHS BY
JERRY N. UELSMANN

University Press of Florida

Gainesville Tallahassee Tampa Boca Raton Pensacola Orlando Miami Jacksonville

This book is dedicated to the friends who shared their Yosemite with me:
Ansel, Jeanne Adams, Ted Orland, David Robertson, William Neill, Glenn
Crosby, Dave Forgang, Norma Craig, and the bears who borrowed our
teabags and gave us stories that are now almost mythic . . . and especially
my wife, Maggie Taylor, a true companion and excellent map reader.

Photographs copyright 1996 by Jerry N. Uelsmann
"A Secret Yosemite" copyright 1996 by David Robertson
"The Landscape of the Mind" copyright 1996 by Ted Orland
Printed in the United States of America on acid-free paper
All rights reserved
01 00 99 98 97 96 C 6 5 4 3 2 1
01 00 99 98 97 96 P 6 5 4 3 2 1
Printing and binding by the Stinehour Press, Lunenburg, Vermont
Book design by Larry Leshan

Library of Congress Cataloging-in-Publication Data
Uelsmann, Jerry N., 1934–
Uelsmann/Yosemite / Jerry N. Uelsmann
p. cm.
ISBN 0-8130-1444-1 (cloth: alk. paper). — ISBN 0-8130-1445-X (paper: alk. paper)
1. Photography, Artistic. 2. Yosemite National Park (Calif.)—Pictorial works. I. Title
TR654.U328 1996
779'.3679447—dc20 95-50346

The University Press of Florida is the scholarly publishing agency for the State University System
of Florida, comprised of Florida A & M University, Florida Atlantic University, Florida International
University, Florida State University, University of Central Florida, University of Florida, University
of North Florida, University of South Florida, and University of West Florida.
University Press of Florida
15 Northwest 15th Street, Gainesville, FL 32611

FOREWORD

Artists have always played a significant role in the establishment and interpretation of America's national scenic parks. The grand vistas and splendors of the wilderness as painted and photographed by nineteenth- and twentieth-century artists led directly to the conservation movement and the creation of the national park concept and the system that now exists.

The Yosemite Museum, a National Park Service unit, established the Artist-in-Residence program in 1987 to recognize the achievements of those pioneer artists and to continue the productive association between the arts and the environment by encouraging contemporary expressions and interpretations of park landscapes and resources.

Each year ten artists are invited to spend a month in Yosemite to study, explore, and experiment in ways to communicate their relationship with the park. Each artist is asked to donate one piece inspired or created during the residency to the permanent museum collection. The photographers who have participated in the program include Ted Orland, Richard Misrach, Michael A. Smith, David Mussina, Jim Snitzer, John Divola, Ken Marcus, David Robertson, Charles Cramer, and, in 1992, Jerry Uelsmann. They have all brought their own vision, experience, and unique body of work.

We had long been familiar with—and impressed by—the work of Jerry Uelsmann through his association with the Ansel Adams Workshops in Yosemite. We assumed that he was an old Yosemite hand and thoroughly familiar with the landscape. We were surprised to learn that this was not the case; while he had taught in the workshops, he had not had the time to explore the nooks and crannies that make Yosemite an infinite source of visual material. We were able to introduce him to some of these; already impressed by his work, we were now also exposed to his wit, enthusiasm, and encyclopedic knowledge of ribald jokes.

Jerry and his wife, photographer Maggie Taylor, have since accompanied us on several Artists' Pack Trips into the Sierra: Ostrander Lake, Sunrise Lakes, Grant Lakes, and this year Green Creek. From these trips the museum assembles exhibits that show how various artists interpret the same landscape through different media, styles, and perceptions.

Jerry's interpretations of landscape elements, reworked, tweaked, and recontextualized, force the viewer to actively interact with his subjects. The energy, the insights, the awakening of inner vision in the viewer that occur in these moments fulfill our aspirations for the Artist-in-Residence program. We hope that Jerry's and Maggie's association with Yosemite will continue to be a long and productive one.

David Forgang
Chief Curator, Yosemite Museum

A SECRET YOSEMITE

DAVID ROBERTSON

Photographer with camera and tripod look out on a magnificent Yosemite scene: a Half Dome of hard rock below soft clouds and between two deep, glacier-cut canyons. The photographer stands on granite, but behind him the stone turns into wood. Cut into the boards is a trap door with hinges and a clasp. Although it is locked tight, it contains an eye that looks straight out at us. If we were to reach into the photograph, and, with a key that we borrowed from Jerry Uelsmann, open that door and look inside, what would we find? Does some sort of secret lie hidden there, deep within the grain of Yosemite's igneous rock?

The idea of Yosemite as the container of an important secret goes back to the beginning of its exploration and visitation by people of Eurasian ancestry. In 1863 Fitz Hugh Ludlow described the canyon of the Merced River (the one to the right of Half Dome in the frontispiece, p. ii) as Nature's "sacred closet." If only he could make his way into it, he would be able to "converse with the King of all the Giants" and "find the silent causes of power." We can understand Ludlow's words on two levels. On one level "the giants" are mountains, and "the King" is the tallest of them. "The causes of power" are the snow fields whose quiet melt yields the thunder of Nevada and Vernal falls. On a deeper level "the giants" are gods and "the causes of power" are secrets of a spiritual nature that human beings want so much to decode.

Ludlow understood what virtually every visitor since his time has felt: that Yosemite is a place where animal/vegetable/mineral meets mental/emotional. In it nature and spirit join hands and become one. Ludlow used the metaphor of a "closet" to express this idea. In the outside rooms is what we see with our two eyes; inside the closet is what we can see with our one inner eye—can see, that is, if we can manage to get the door open. Other writers have used a different metaphor to make this same point about Yosemite: it is not a closet within a house but a heart inside a body. Most often the body is the mountain range where Yosemite is situated: it is the "heart of the Sierra Nevada." Ansel Adams made the body bigger. He believed that Yosemite was at the heart of the earth: "The great rocks of Yosemite, expressing qualities of timeless, yet intimate grandeur, are the most compelling formation of their kind. We should not casually pass them by for they are the very heart of the earth speaking to us." Cora Morse made the body within which Yosemite beats no smaller than the cosmos itself. "Ah Yosemite!" she declared. "Thy heart holds the secret of the Universe."

Jerry Uelsmann would, I think, agree wholeheartedly with the sentiments expressed by Morse and by Adams, who was a close friend of Uelsmann's and, by means of invitations to Yosemite photographic workshops, the person most responsible for his long association with the park. But metaphorwise, Uelsmann is in the Ludlow tradition. Continually in his photographs we walk up to entrances. It may be a gate (page 7), a window (page 46), a trap door (frontispiece), or ordinary doors (pages 45, 48, and 59). Even if the entrances are not shut, as they usually are, he does not allow us to see inside. We must imagine what is inside. And so, we return to the question: were we to go in, what would we find? What is the secret that Yosemite holds, according to Uelsmann? One trail to follow in pursuit of an answer to this question is the history of Yosemite photography.

Actually, Yosemite photography consists of two main trails. Along one trail all we see is Yosemite scenery, and it is grand indeed. People and people's accessories are almost never visible. This path goes by the studios of Carleton Watkins, Eadweard Muybridge, and Ansel Adams, as well as by the more recent showcases of those who are printing the Adams aesthetic in color as well as black and white. The other trail takes you by scenes with humans and human artifacts in them. This path is the less traveled one. The views are generally not so magnificent—in fact, they can be quite cluttered—and

the aesthetic is usually more complicated. If you continue past the works of George Fiske and Ted Orland, you will come to *Uelsmann/Yosemite.*

And what a difference Uelsmann makes! Actual people appear in the photographs of Fiske and compatriots, artists such as Arthur Pillsbury, Daniel Foley, Julius Boysen, and their contemporary progeny. Uelsmann's Yosemite, on the contrary, is "peopled" almost exclusively by studio models and angels, Roman heads and Buddha figures, not to mention Jesus and the evangelists. To be sure, Ansel Adams is there, a very real person. But only his smiling face shows, stenciled in silver on the larger face of Half Dome. He has no body. Or, better, the granite itself has become his body. The Uelsmann difference also shows up in his field guides to the local fauna. There are owls in Yosemite, but they are stuffed. There are rabbits in Yosemite, but they are mechanical.

What happens when Uelsmann "peoples" Yosemite with all these exotic creatures is, first of all and most of all, an imaginative and highly original vision of the park. For most people, artists and lay persons alike, the course of Yosemite photography arrived at a very lofty peak in the work of Ansel Adams. Such exalted accomplishments, whether in literature (like the poems of T. S. Eliot), or music (like the scores of Stravinsky), or painting (like the canvases of Picasso), produce feelings of vertigo in the next generation of artists. How can they make art that is fresh and original? Jerry Uelsmann arrived in Yosemite near the end of the Ansel Adams era ideally prepared to do just that.

He came from Michigan, where he was born; from New York, where he was an undergraduate; from Indiana, where he did his graduate work; and from Florida, where he now lives. All of these places are east of the Mississippi River. To an important extent, photographers in the East had different notions from those in the West about what a photograph was supposed to look like. In the East, people were more in than out. A more radical manipulation of the final image was permitted, even encouraged. A greater freedom was granted artists to use the traditions of psychology, especially the theories of Freud and Jung, to express the inner states of being of themselves and their subjects.

Uelsmann arrived in Yosemite from the East carrying only one camera. I doubt that this was ever literally true. Symbolically, it was definitely true. "Most photographers I know carry many cameras with multiple attachments. I carry one. Most photographers I know have one enlarger. I have half a dozen." These were just about the first words I heard him say when we first met at an Ansel Adams Gallery workshop in the early 1980s. The important point is not whether he really had come from Florida packing only one camera. Of fundamental importance is his attitude that the photographer can and should interject his imagination and vision into every step of the photographic process. According to a somewhat idealized version of the West Coast tradition, the photographer stepped into the process at the moment of exposure in order to obtain the best possible negative and then stepped back out again. From release of shutter to final print was a matter of allowing initial expressive decisions to play themselves out with minimal interference from the artist.

Uelsmann also arrived in Yosemite with a wonderfully weird sense of humor. So much so that the first reaction to many of his Yosemite images is likely to be laughter. Flamingos in Yosemite Valley? A dolphin in the Merced? Angels on the rocks? Shadrach, Meshach, and Abednego in a tree furnace? Surely this sense of humor came from strands of DNA rather than from his education or his aesthetic philosophy. I suspect that humor is born not made, especially a humor that bears so obviously the stamp of individuality. His education and aesthetic played important roles, however. They encouraged him to use his wit in the making of photographs. After all, the personal playfulness of Ansel Adams is legendary, but no hint of it surfaces in his Yosemite landscapes.

Uelsmann uses his sense of humor partly to make an ironic commentary on Yosemite as it exists today. He is one of many artists working in the park during the last quarter-century or so who have insisted that we see it as it is and not as we romantically and nostalgically wish it were. It is full of people and their things, more so in the front country of Yosemite Valley but also in the backpacking territory of knurled junipers and glacial lakes. Yosemite has become, at least in significant part, a theme park as well as a museum (with middens heap). Uelsmann presents it as such. Yet he is a gentle critic. Never does his critique assume savage proportions. Always his bite is muzzled by his taste for the comic.

Uelsmann's larger purpose is not to make Yosemite a lesser place or to persuade us to take it less seriously. He wants us to take it seriously as another kind of place. It is not pure wilderness, nor has it been pure wilderness for however many thousands of years Native Americans have made it home. But it is, nevertheless, a perfect place for magnificent nature and imaginative human beings to meet. With respect to the out-of-doors, Americans have often set before themselves an ideal goal: a deeply meaningful and not

just casual union with nature. It is arguable that many, if not most, travelers to Yosemite come in search of this goal. Uelsmann's work belongs in this context, a long tradition that includes the works of Ralph Waldo Emerson and Henry David Thoreau as major signposts. In my opinion, few Americans have so effectively as Uelsmann rendered in art the union of the human with the natural.

So, if we open the door that Uelsmann has built into the granite floor of Glacier Point, what would we find? The answer is: the photographs in this book. Locating a key to the padlock is unnecessary. All we have to do is keep turning these pages. The secret that Yosemite and Uelsmann together hold in common is that wildness on the outside is wonderfully matched by wildness on the inside. Look outside at geological and biological forms, and you will see wild forces. Look inside yourself and inside your fellow human be-ings (and even inside other animals) and you will find wild imaginations. Wild imaginations unite with wild forces through play. To make and to keep insisting on that very point is the most important function of humor in Uelsmann's photographs.

We typically think of secrets as capable of being said. Whisper it to me, we are likely to say to someone who confesses to holding a secret. Indeed, in the above paragraph I have tried to render in words the secret I believe Uelsmann shares with Yosemite. But this particular secret is better thought of not as words but as activity, namely the activity of the wild mind engag-ing the wild universe in play. That old American goal of becoming one with our environment turns out to be, in the work of Jerry Uelsmann, nothing more or less than playing actively and imaginatively with the forms and forces of nature.

THE LANDSCAPE OF THE MIND

TED ORLAND

There is only one road through Yosemite Valley, and it offers the same view to all. But what each person sees—now that is another matter entirely. Traveling with Jerry Uelsmann brings that lesson home real fast. We were driving that familiar Valley road one day, Jerry and I, when suddenly a gawky, twenty-foot-tall, five-legged oak tree ambled right across our field of view. It is unwise to refuse such gifts from the photo gods, so within seconds we abandoned the car and began flailing our way through the tall meadow grass in clumsy pursuit.

And months later a photograph—reproduced here on page 41—emerged from Uelsmann's darkroom. Now we all know that if Ansel Adams titled one of his photographs *Branches, Meadow, Yosemite Valley*, we'd pretty well know what the picture was all about. But what would you call this vision from Jerry Uelsmann—*Walking Tree (Right-Handed), Glowing Cloud, Yosemite*? Clearly this is not your traditional Adamsonian landscape.

Nor should we be surprised. All photographers strive to imprint their personal vision upon each new image they make—after all, that's their *job*. The surprise is Yosemite itself, which has proven a perversely difficult place to achieve that goal.

Consider it a fluke of history: Yosemite is not only the last great American wilderness area discovered by the white man—it is also the only one discovered after the invention of photography. As such, the first photographs there were taken just as America's sense for what the landscape *meant* was beginning to coalesce. By the close of the nineteenth century, Yosemite was knee-deep in photographers—really good photographers like Watkins, Muybridge, Boysen, and Fiske. Collectively their images defined the romantic ideal of a natural landscape: pristine, benign, and monumental.

In this century, Ansel Adams championed that nineteenth-century vision with eloquence and precision. If you compare Adams' photographs with those made by his predecessors, what is striking are not the obvious technical differences, but the obvious aesthetic similarities. Conceptually speaking, Ansel Adams was the last great defender of the Newtonian universe: perfect in its infinite detail, its revelation limited only by the clarity of vision and technical facility of the artist. Such was the force of Adams' vision that when he departed the scene in 1984, precious few twentieth-century interpretations of Yosemite had ever been attempted. Photographically speaking, Yosemite was waiting to be rediscovered.

Discovery, for the artist, is a matter of noticing things. Consider, for instance, something as simple as the lines in a pencil sketch. Sooner or later every artist (and viewer, for that matter) notices the relationship of the line to the picture's edge. Before that moment the relationship does not exist; afterwards, it's impossible to imagine it *not* existing. And from that moment on, every new line talks back and forth with the picture's edge. People who have not yet made this small leap do not see the same picture as those who have—in fact, conceptually speaking, they do not even live in the same world. Similarly, if you peg Adams' conceptual universe as Newtonian, then by contrast Jerry Uelsmann's is undeniably Jungian—a place where angels linger, paradox abounds, and the earth at times yields darker secrets.

But having said that, I will quickly add—and trust me on this one—that the first time Jerry reads the preceding sentence he's going to roll on the floor laughing. (Artists are like that.) Uelsmann addressed the issue of meaning in his images early on. "I think of my photographs as being obviously symbolic," he concluded, "but not symbolically obvious." Now there's a refreshingly healthy response! In Uelsmann's art there are many right answers—and discovering them is a process that involves both artist and viewer.

His approach reminds me of the time designer Charles Eames created a museum exhibit describing the complete history of mathematics—illustrated entirely in textbook-sized type and miniature illustrations on a twenty-foot-long wall. Incredulous museum staffers stared at the wall, stared at Eames, stared at the floor, until finally someone blurted out, "But who could possibly understand all that?!" Eames, unperturbed, calmly allowed as how each

viewer would probably absorb about as much as he or she was able to, and just slough off the rest. And among that audience, he predicted, would be some who would make connections among the data beyond what he himself could conceive. Jerry Uelsmann, to his endless credit, grants his own audience that same intelligence and perception.

As viewers, however, we're often surprisingly reluctant to credit ourselves with such insight. The popular myth is that some mysterious gulf—usually called "genius" (or occasionally, "madness")—forever separates us from the artists we admire. Artists know better. The common ground shared by every successful artist I've ever known goes by another name: *work*. They all work incredibly hard, all the time. And with good reason: that's how they improve. In his book *Process and Perception*, Uelsmann describes his typical darkroom day—an account he spikes with reproductions of eighteen successive test prints that didn't work. From those eighteen prints, however, evolved the ideas and imagery that led to a nineteenth. Which *did* work. Lesson for the Day: even the failed pieces are essential. The function of the overwhelming majority of any photographer's work is simply to lay the groundwork for the small fraction that soars.

Uelsmann's own sense is that he "doesn't have a privileged sensibility, in the sense of effortless inspiration" in the making of his art. What he does have is a strong intuitive sense of what he's looking for, some strategy for how to find it, and an overriding willingness to embrace mistakes and surprises along the way.

Back when view cameras ruled Yosemite, few photographers doubted that everything they could focus their lens upon was really there—and that anything they couldn't, *wasn't*. Oh, there were a few emotional overtones to account for—the majesty of El Capitan, the delicacy of Bridalveil Fall, things like that. Still, the mandate of landscape photography was clear: interpret the natural scene with grace and fidelity. The working approach is called pre-visualization and it couldn't be more straightforward: squint at the forest until you can picture in your mind's eye the way it should look as a finished photographic print. The rest is craft (or maybe attrition)—wrestling with technology to make the end result fit the pre-visualized template.

That was then, this is now. Consider this (true) tabloid adventure: there we were again, Jerry and I, standing beside one of the Sunrise Lakes at some ungodly hour of the morning. (Well, sunrise, to be exact.) Jerry carefully adjusts his camera and tripod, waves his light meter in the manner of a priest giving benediction, patiently waits for that decisive moment when absolute stillness blankets the water's glassy surface—and then picks up a huge rock and hurls it thirty feet out into the lake! SPLASH . . . long pause . . . *click*. Well, there you have it: another master photograph in the making. No, not the Sierra Nevada mountain range. Not even the lake. *The ripple*.

Now I have no idea how Jerry intended to use the resulting image—and at the time, I'm fairly certain, neither did he. Pre-visualizing a Uelsmann photograph from the initial exposure is, well, unlikely. The artist himself coined a better term for his art-making process: post-visualization. A wise choice, considering that most other photographers print their images from one negative. For that matter, most other photographers expose their Yosemite images *in Yosemite*.

Admittedly, it might seem that whatever's right in front of you is the only thing you can photograph, given that the very act of photographing is so intensely experiential. After all, your camera rarely goes backpacking on its own, rarely peers into the forest unless you point the way. But as Uelsmann himself has noted, photography is also autobiographical in a much larger sense. Every image you collect on film registers simultaneously in your mind, making every click of the shutter an emotional investment in your own experience.

Even images of demonstrable fantasy remain *emotionally* autobiographical. John Szarkowski once curated a show at the Museum of Modern Art he titled *Mirrors and Windows*. His premise was that some photographers use the viewfinder as if looking through a window at things happening "out there," while others treat it like a mirror reflecting a world inside themselves. Uelsmann bridges that gulf, taking in optical reality and offering back a landscape of the mind.

There is a Zen parable about the artist who approached the Master and asked, "How can I paint the perfect picture?"

"It is easy," replied the Master. "Simply lead a perfect life, and by its nature the pictures you paint will also be perfect."

Yeah, right. On the other hand, a flawless person probably wouldn't need to make art. It's difficult to picture the Virgin Mary painting landscapes. Or Superman spotting prints. Fortunately for us, Jerry Uelsmann does not lead a perfect life. He does, however, lead an *interesting* life—and I would maintain (as my modest contribution to art theory) that if you lead an interesting life, you will create interesting art. How could it be otherwise? Watching Uelsmann photograph in Yosemite suggests that theory; spending a day with him in his studio and darkroom confirms it.

Uelsmann's in-home studio resembles nothing so much as some over-stocked secret archive of the Smithsonian. Every available surface is carpeted in fuzzy memorabilia, stretching to all the corners and then unrestrainedly climbing the walls. Mickey Mouse telephones, McKinley for President posters, "Save the Chocolate Mousse" bumper stickers, extinct cameras, stuffed unicorns—imagine it and you'll probably find it, lovingly placed in some carefully chosen niche. It's like walking around inside one of his photographs.

Jerry begins a printing day by covering a large drafting table with hundreds of dog-eared proofsheets—enough, certainly, to make you a believer in Chaos Theory. By folding and overlapping various contact prints, he explores their visual possibilities—and soon enough, armed with a small bundle of likely candidates, disappears into the darkroom. The darkroom itself is rather reminiscent of Captain Nemo's submarine—an eclectic mix of large machines entwined with Victorian ornaments and lush background music. It's also better equipped than most New York City camera stores, with an entire bank of matched enlargers hovering above matched easels and matched sundries. So on this particular day, rather than juggling negatives constantly, he simply set up a different piece of his forthcoming four-negative photograph in each enlarger—and moved the photo paper progressively down the line, building up a latent image en route.

Creating new worlds is strenuous business, so afterward we relaxed and celebrated with Florida pizza and California wine and lots of animated storytelling. And later that evening, Jerry—sporting a giant cigar in one hand and a *kazoo* in the other—plunked himself down at his mechanical player-piano to harmonize at full volume with the pedal-generated chords of Beethoven's Ninth Symphony! It was an inspired performance—and exactly what I would expect from the man who only hours earlier had introduced flamingos to the Merced, and Ansel Adams to the face of Half Dome.

When all is said and done, a piece of art is the surface expression of a life well lived. Over time, the life of a productive artist becomes filled with useful conventions and practical methods, so that a string of finished pieces continues to appear at the surface. And from that secure place flow the artistic gestures that link form and feeling, and give the work a life all its own. These elements become—like the angels and paradoxes that thrive in Uelsmann's photographs—inseparable from life of their maker. It's strange, but for years I thought the secret to understanding those pictures lay in deciphering all those amazing juxtapositions. And then one day, quite unexpectedly, I suddenly understood: *there are no juxtapositions*. Jerry Uelsmann's Yosemite is a world complete unto itself—and if someone viewing the photographs in this book should ask, "But is it really like that?" the only possible answer is: *it is now*.

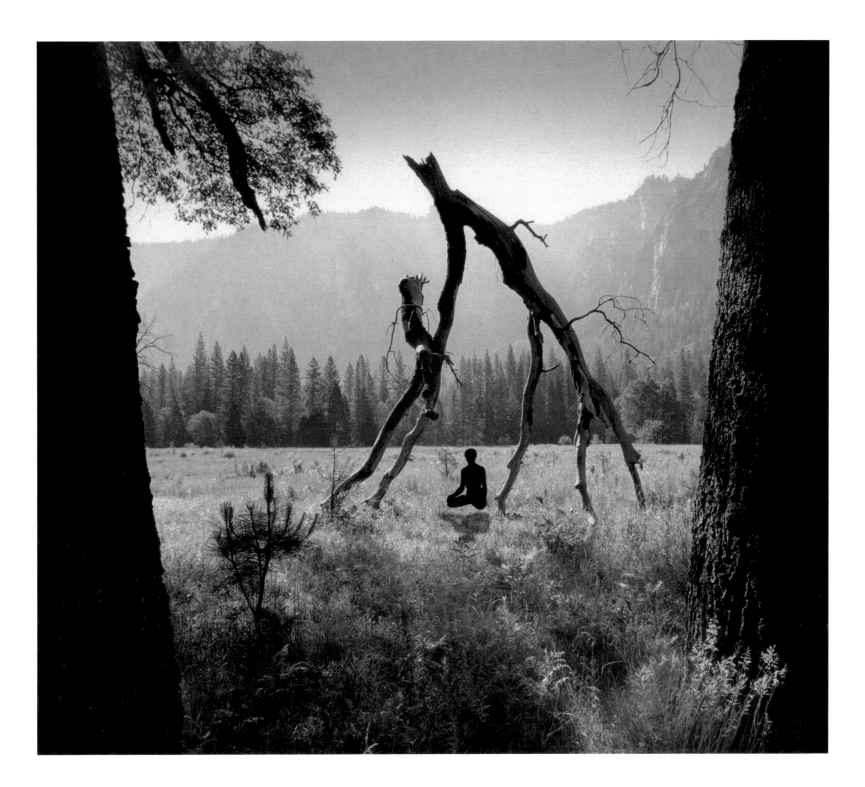

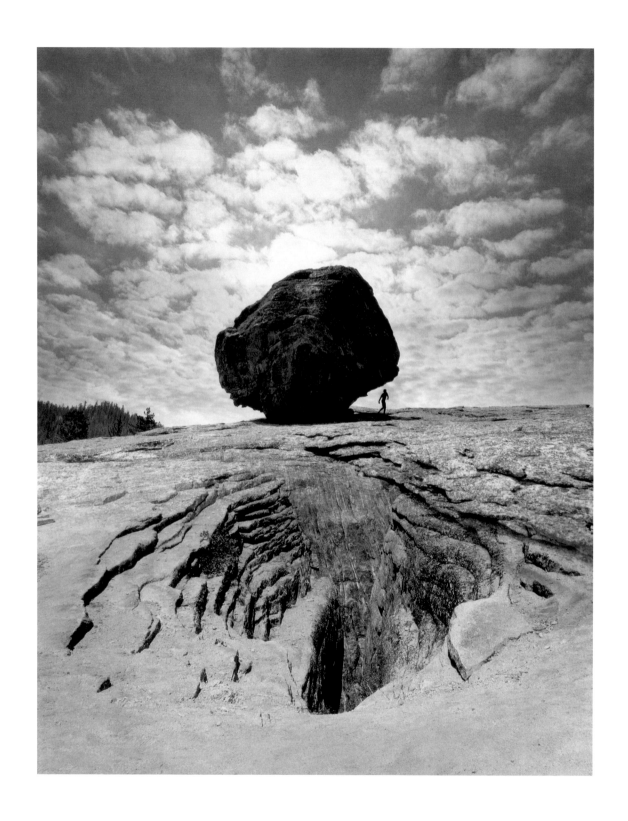

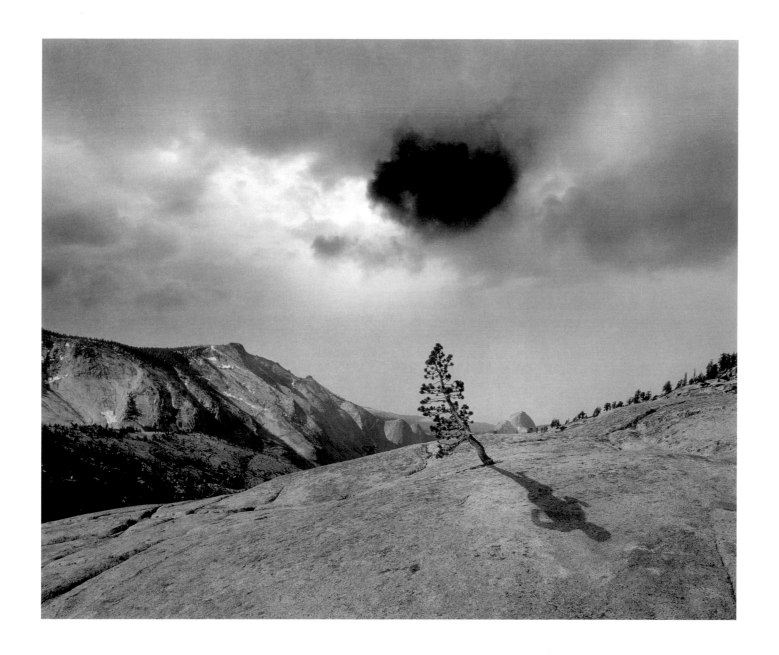

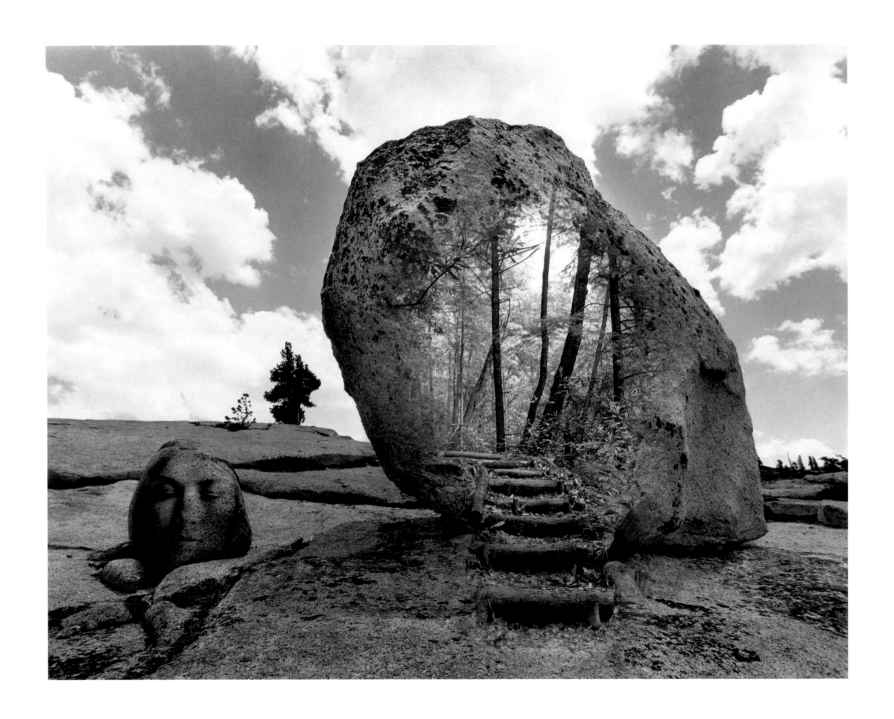

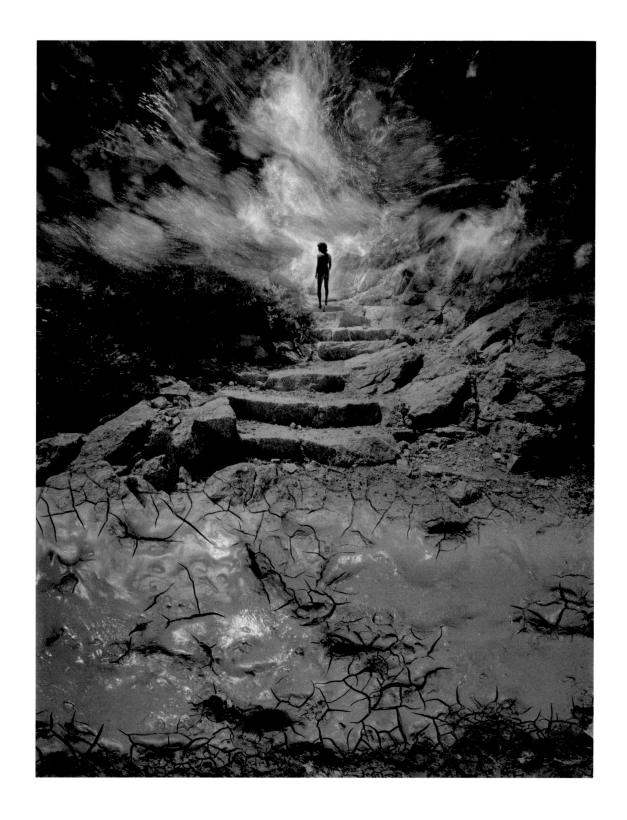

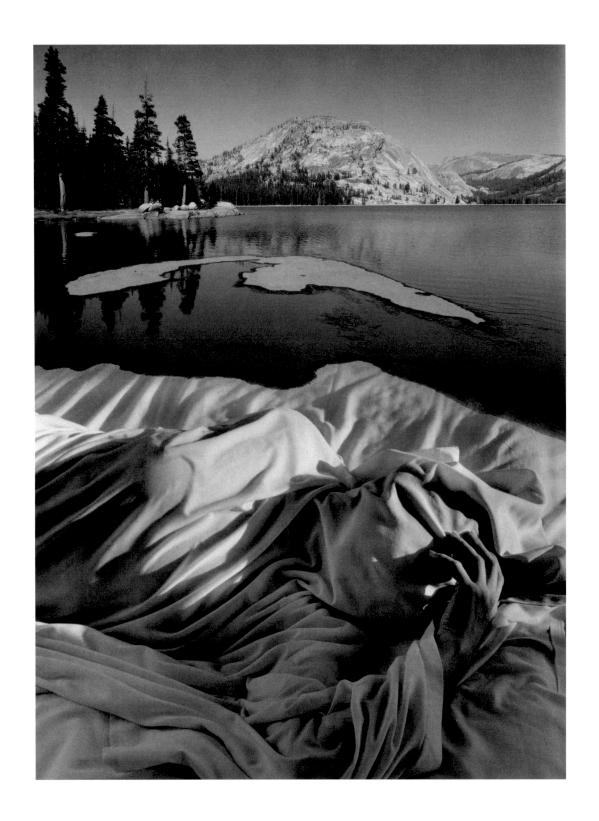

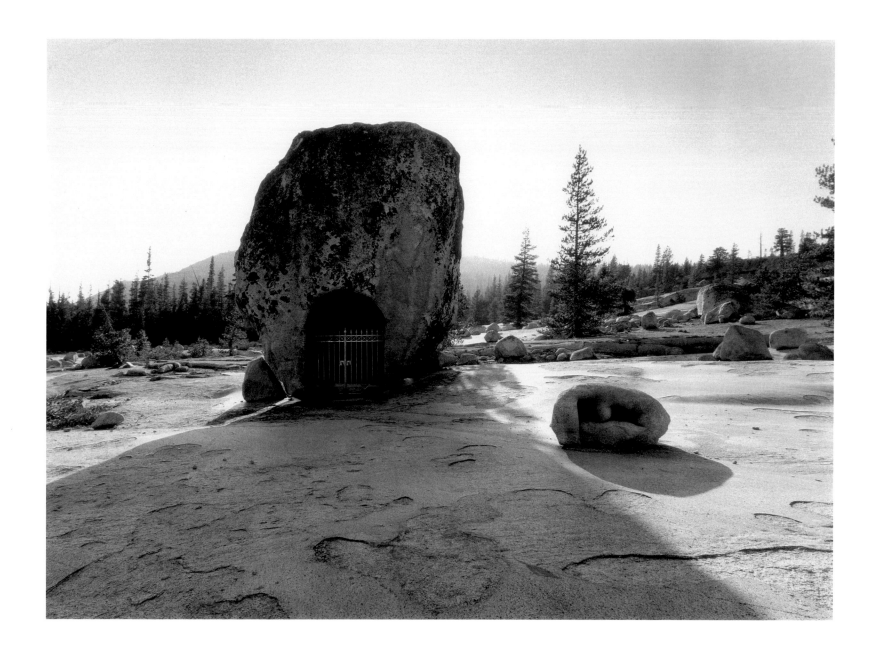

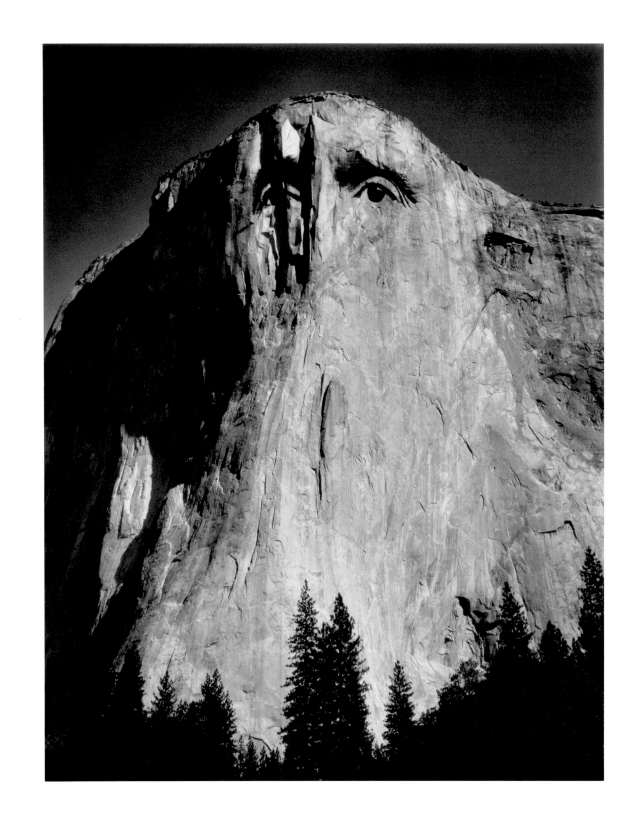

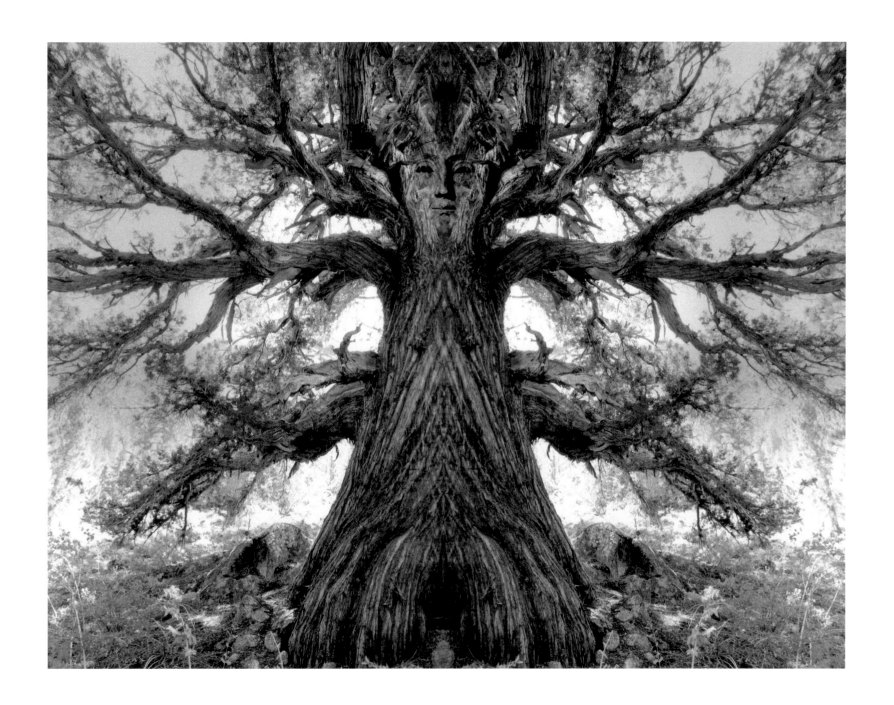

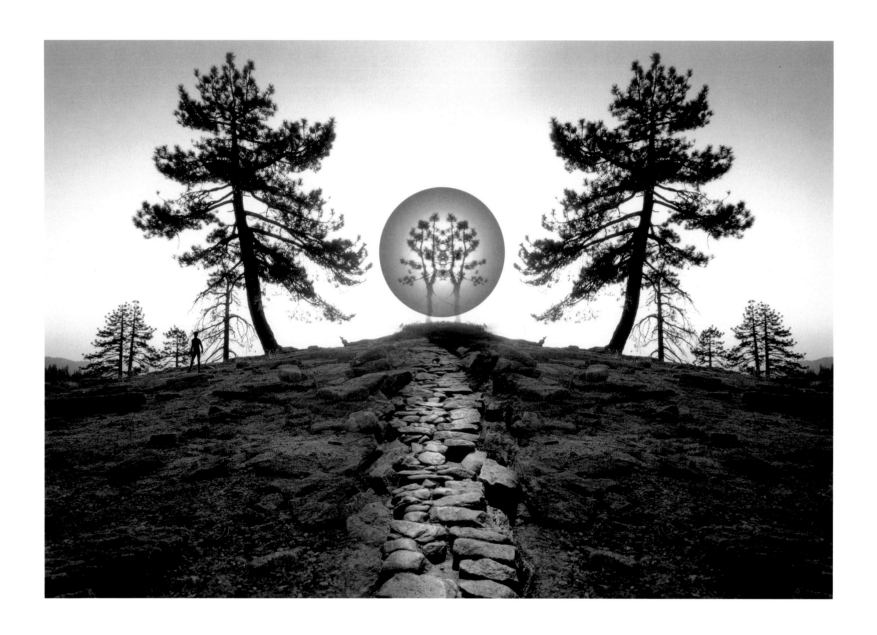

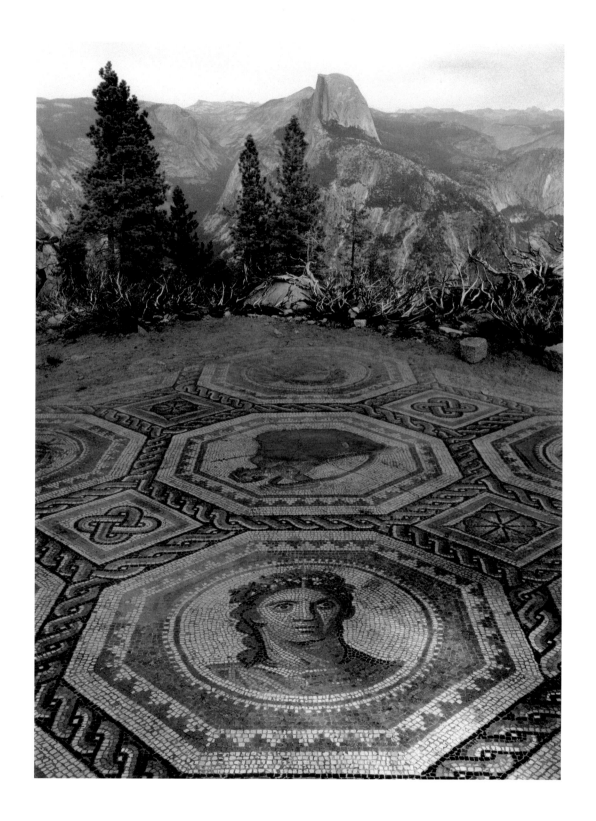

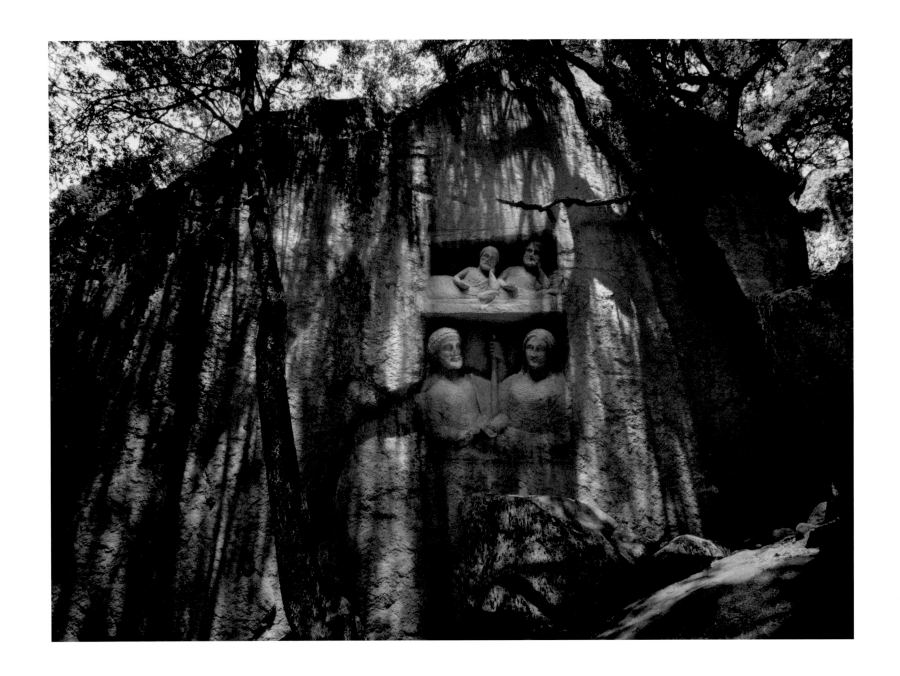

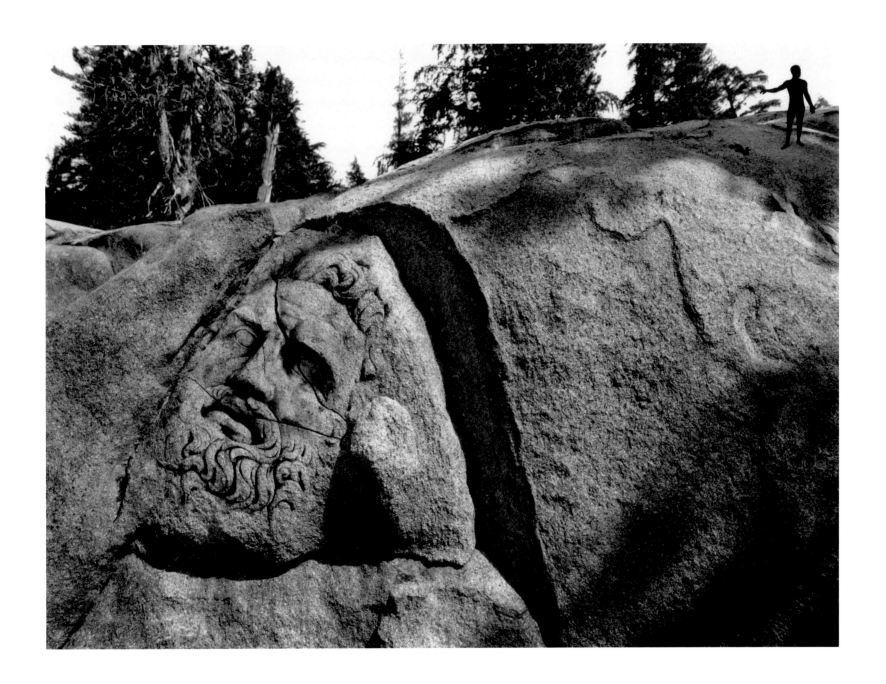

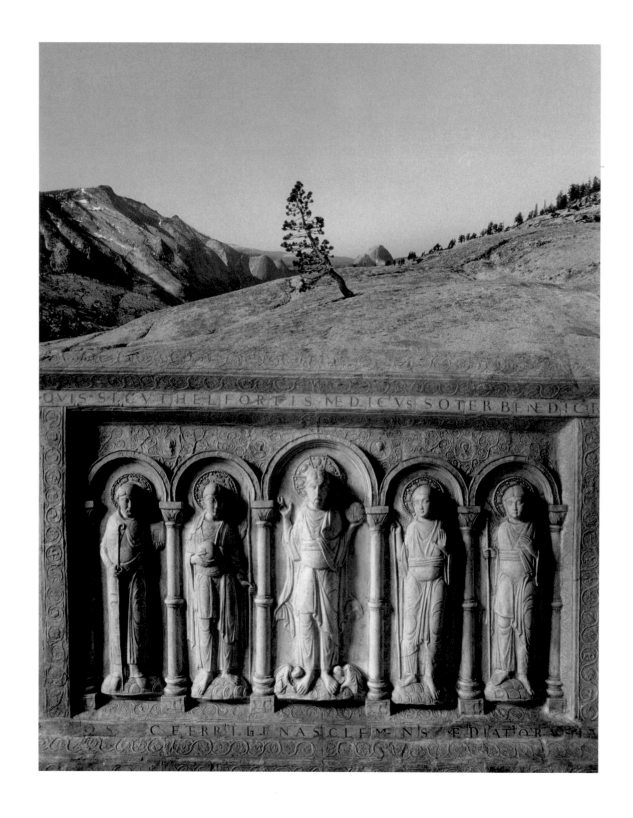

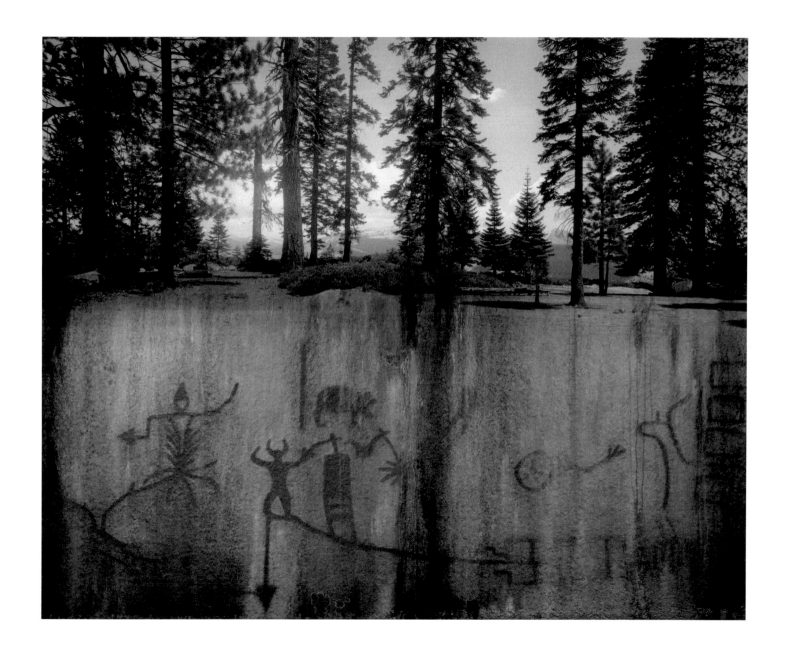

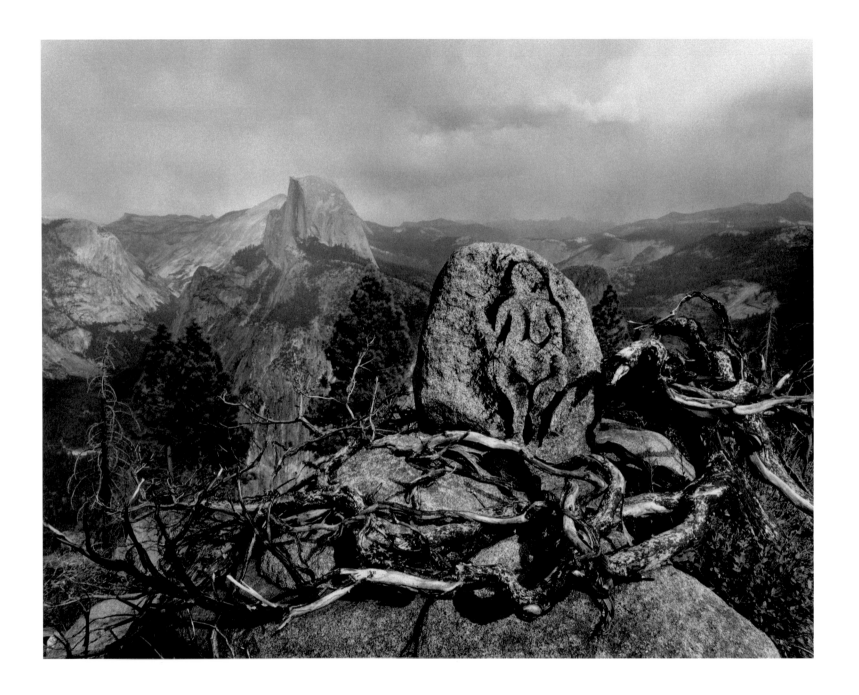

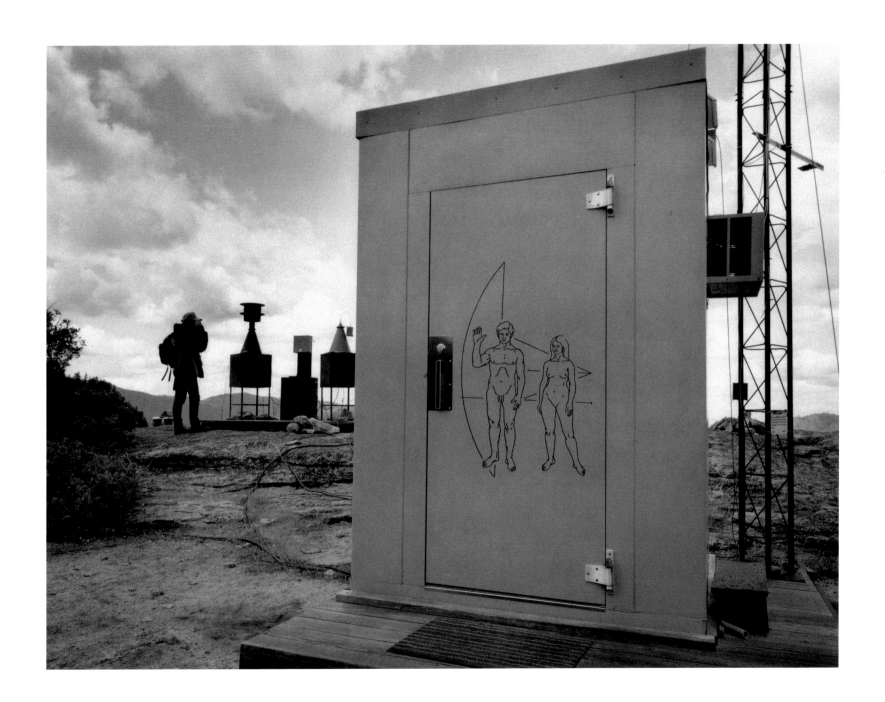

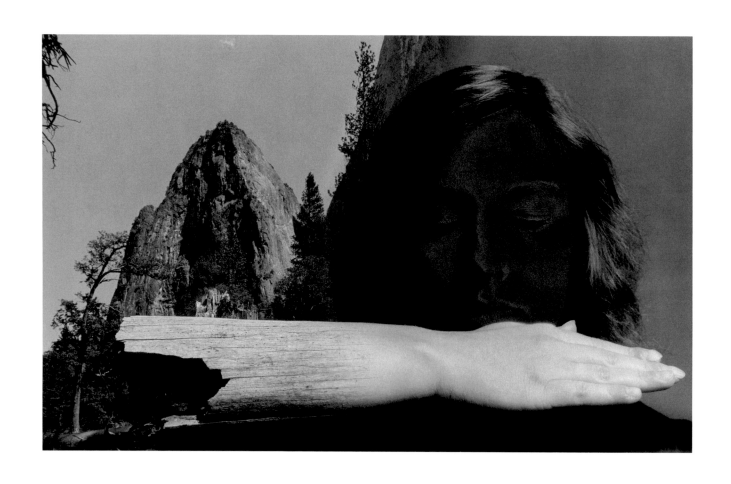

18 / 1987

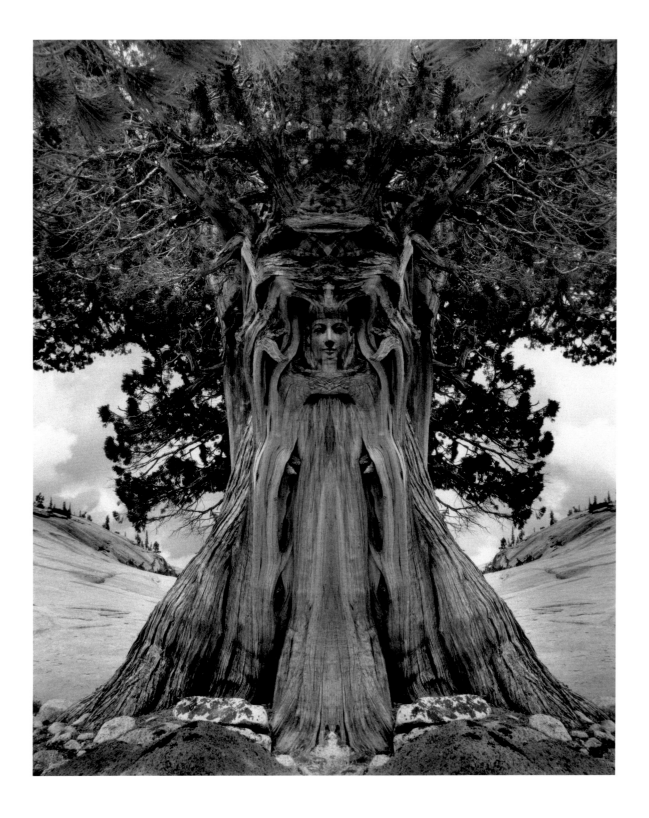

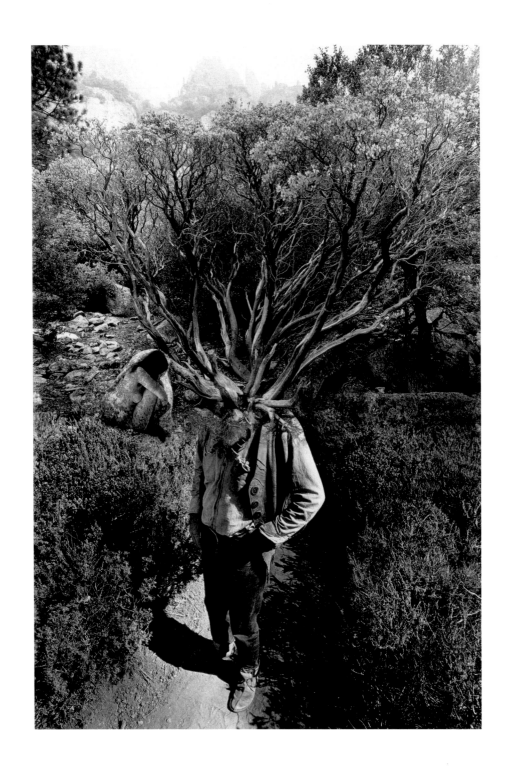

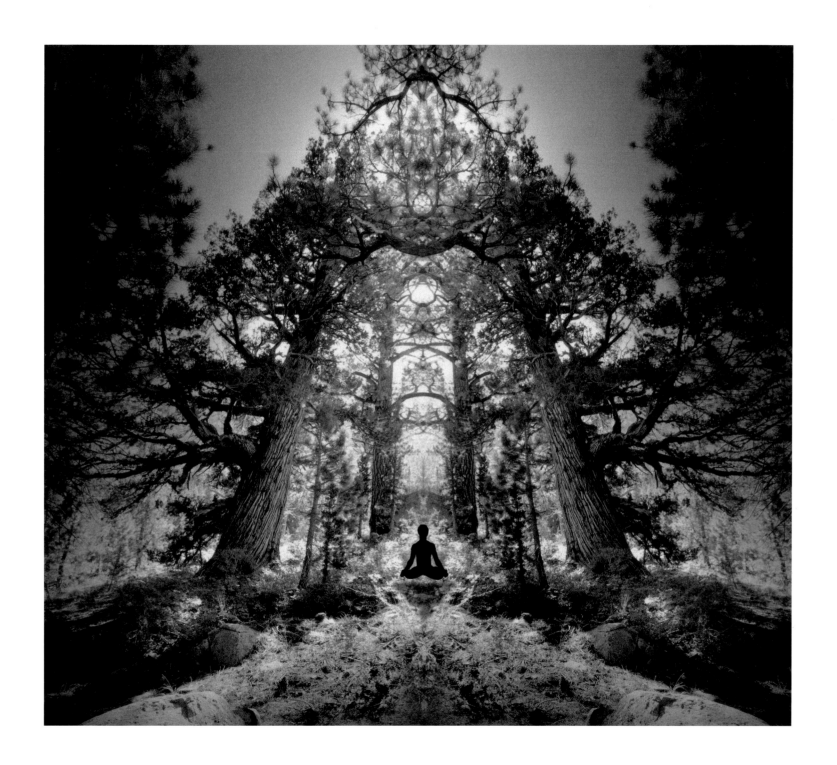

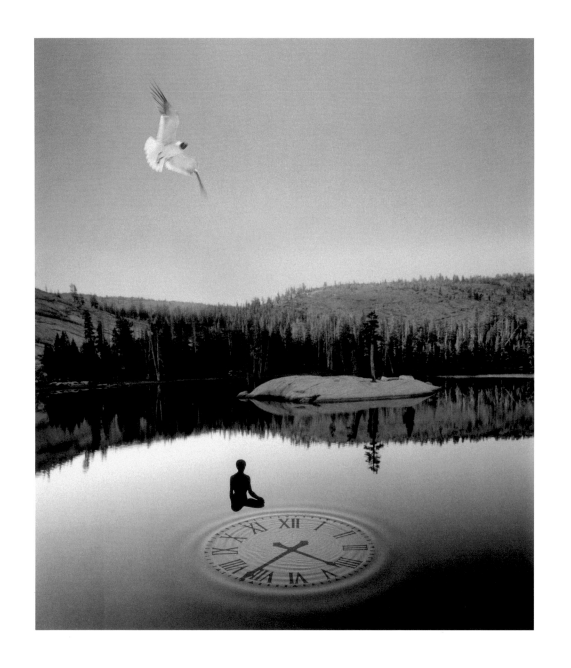

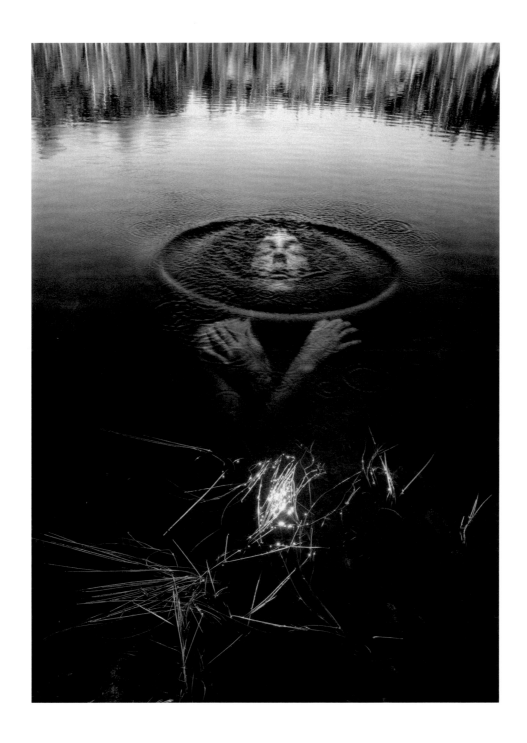

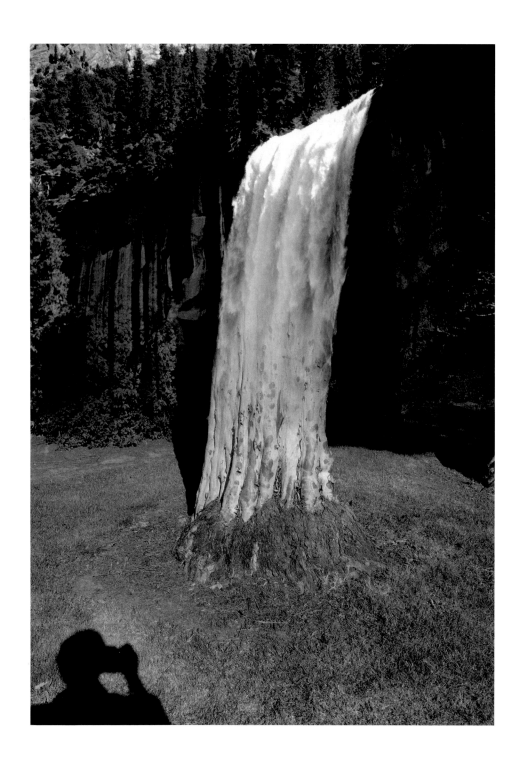

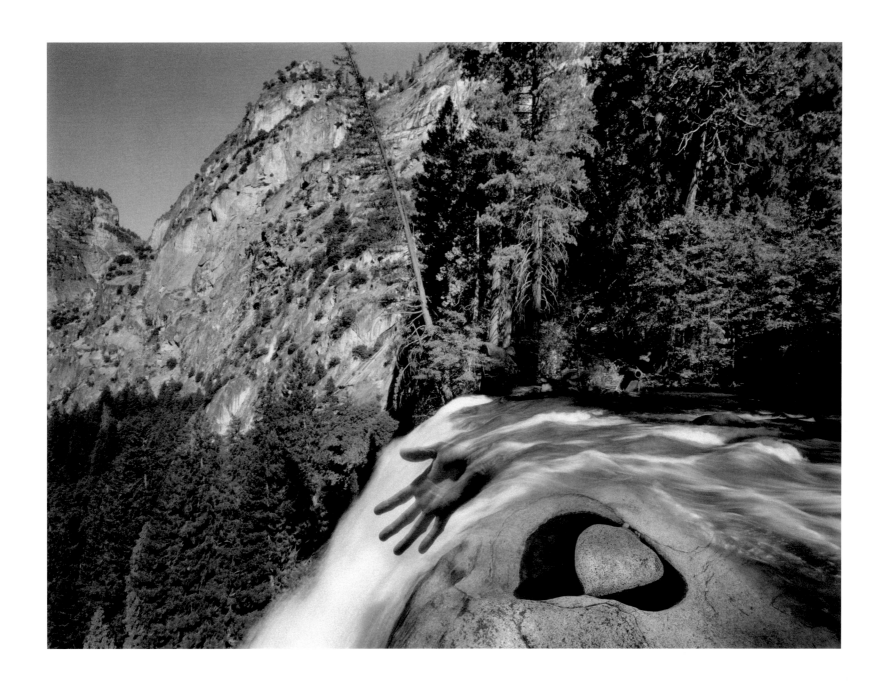

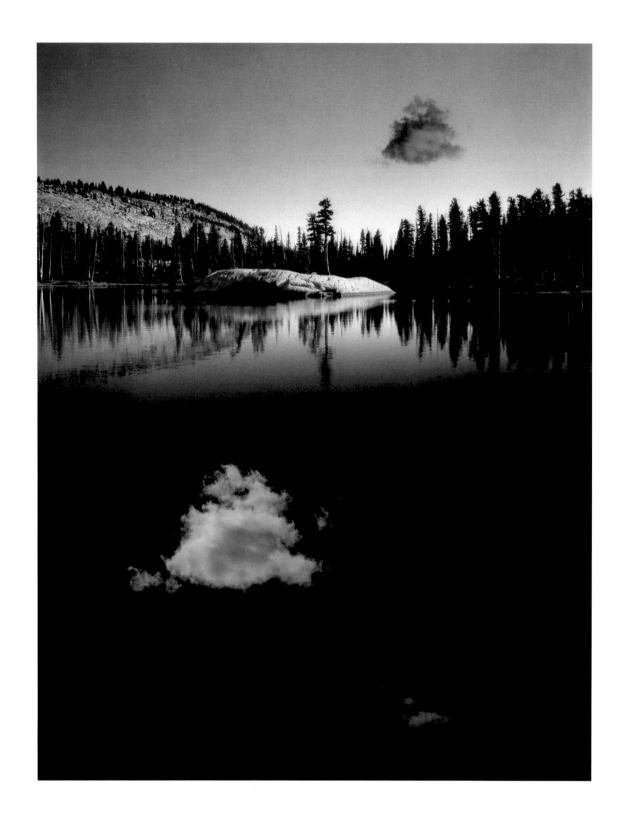

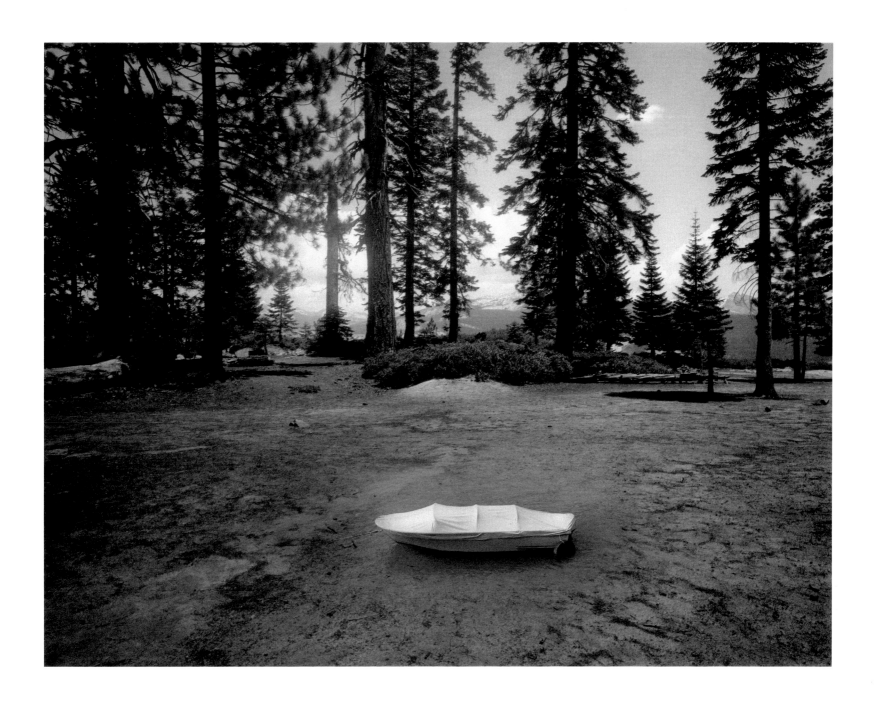

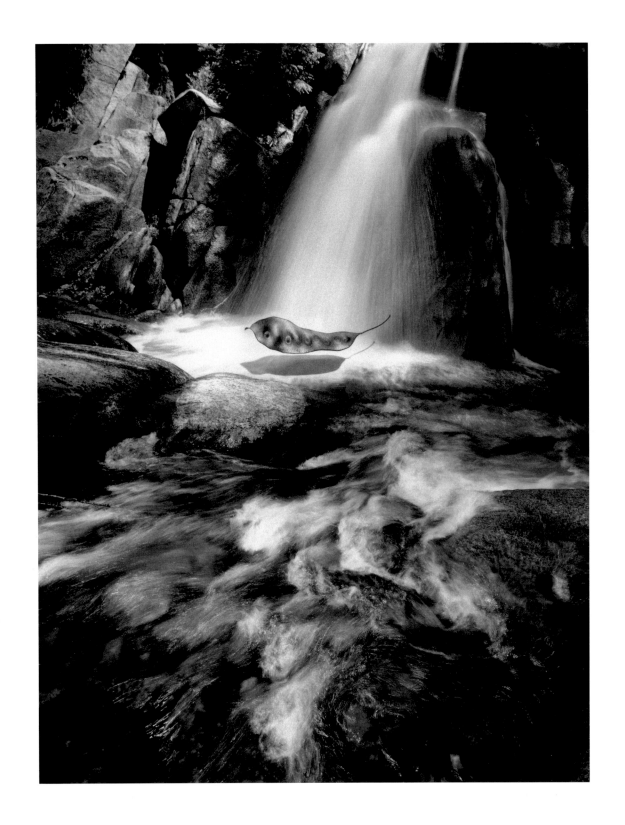

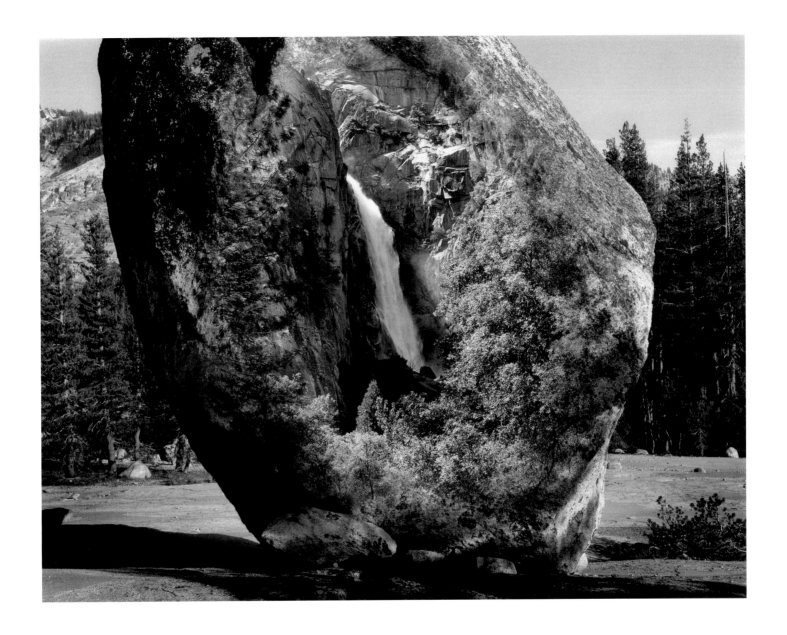

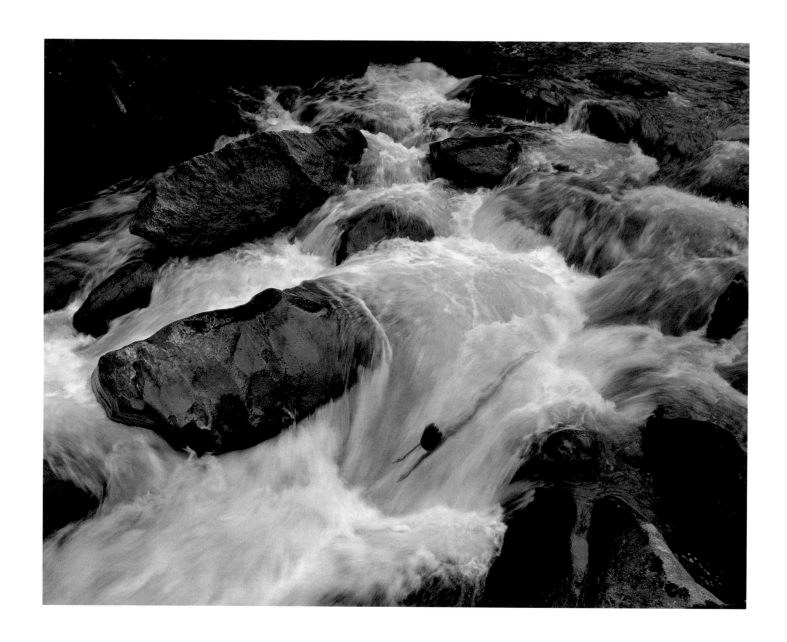

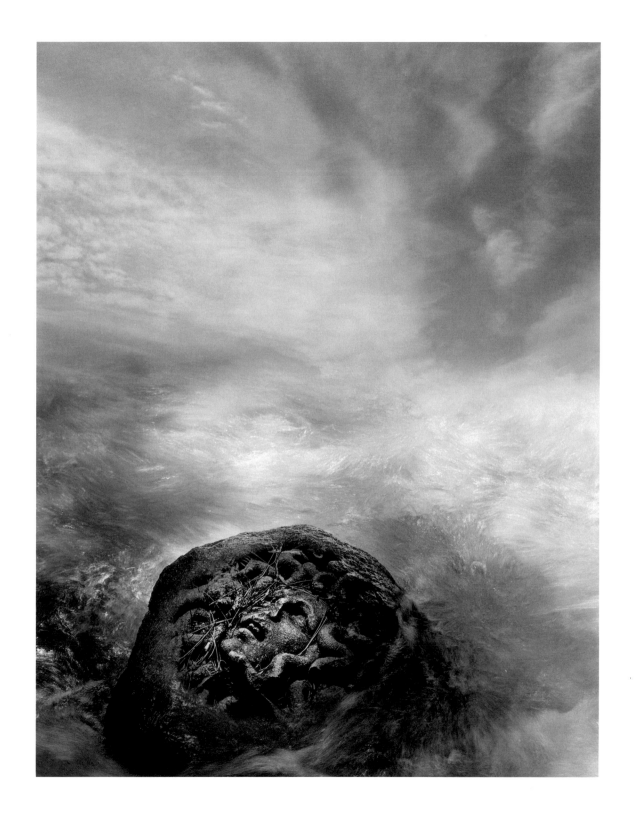

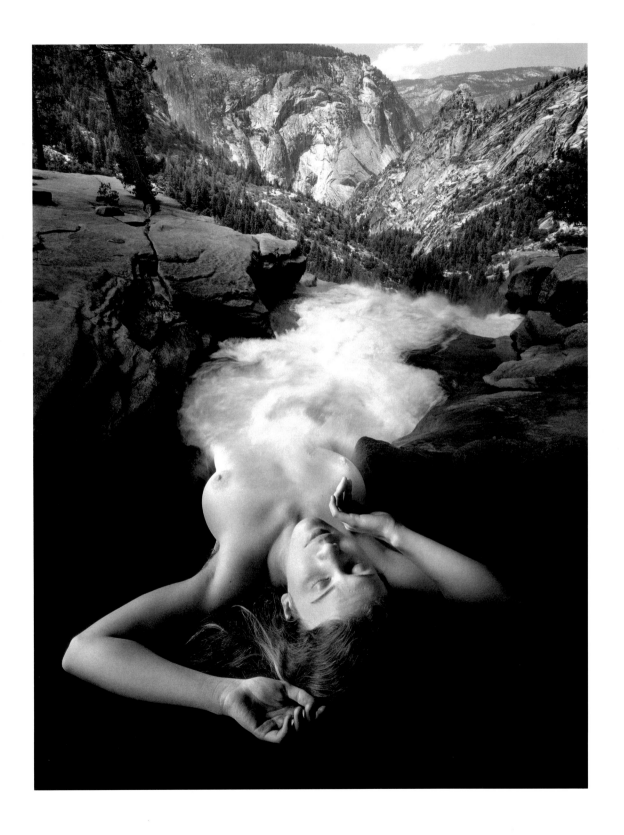

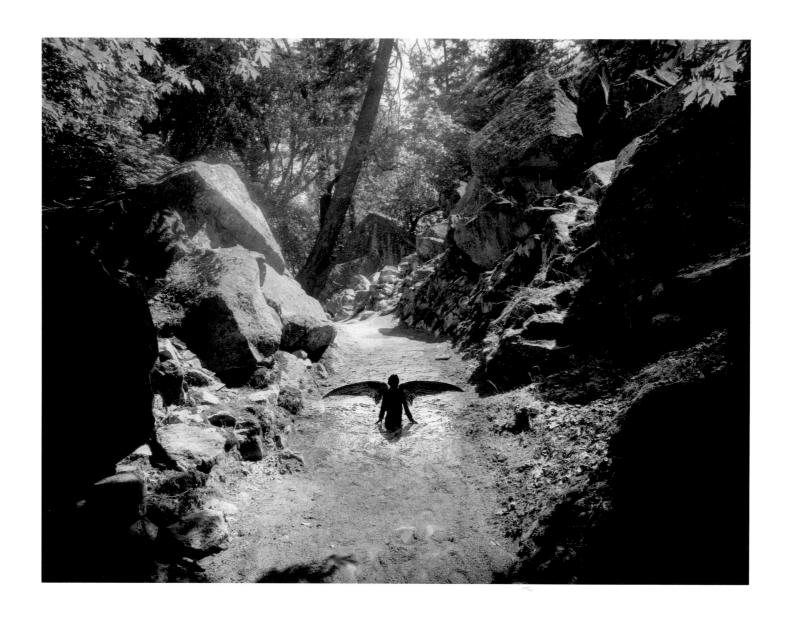

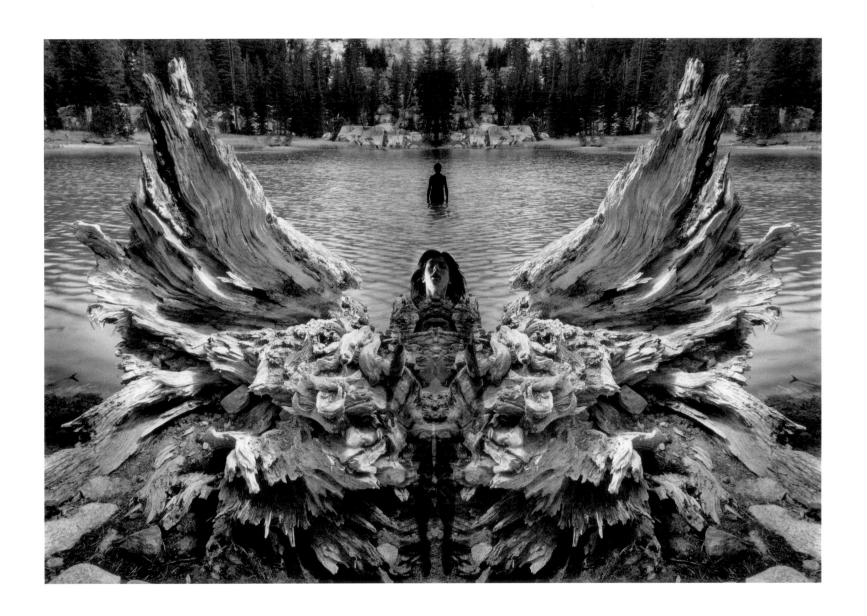

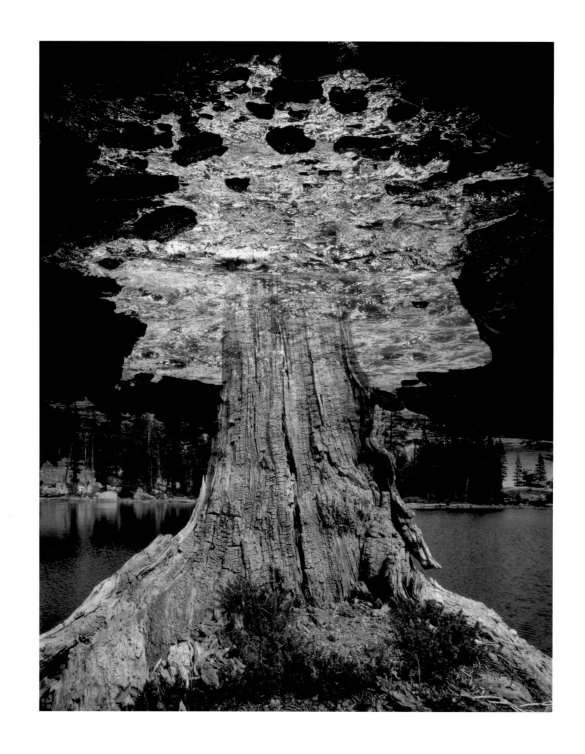

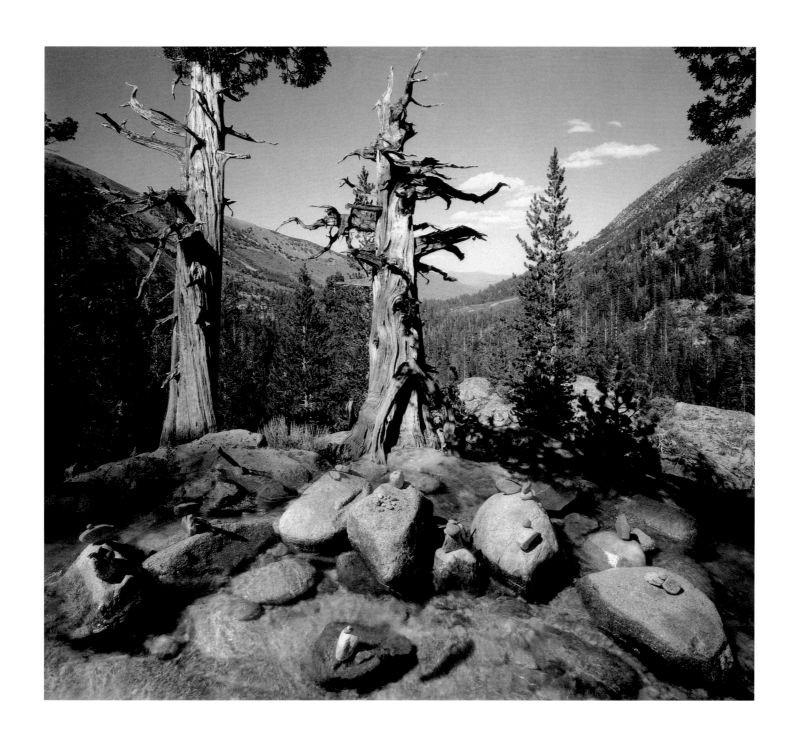

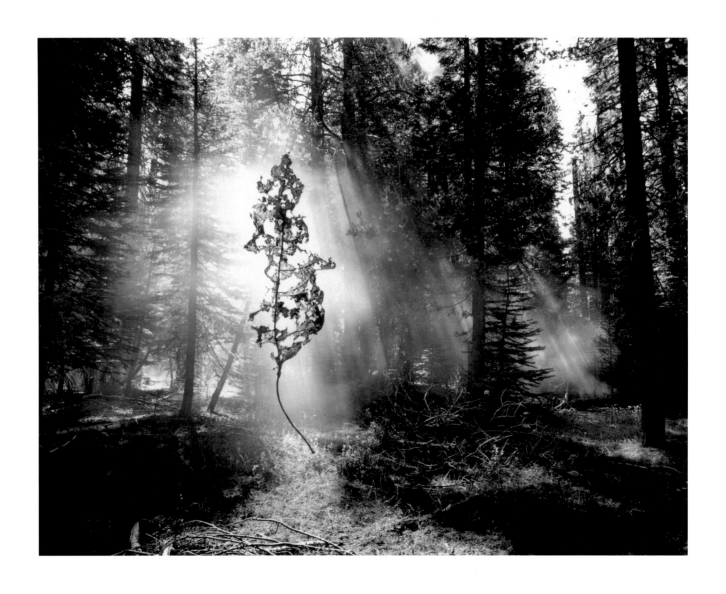

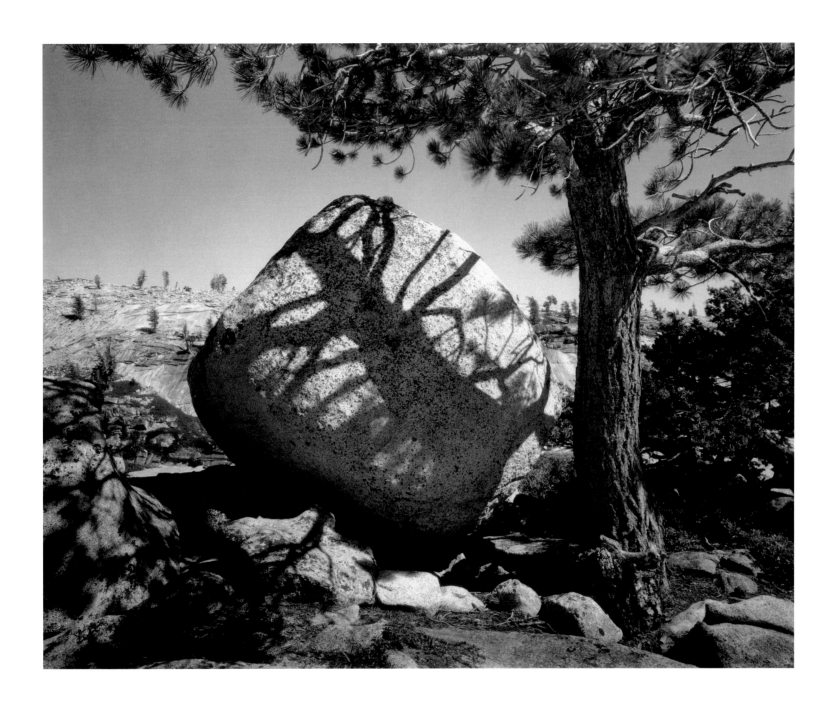

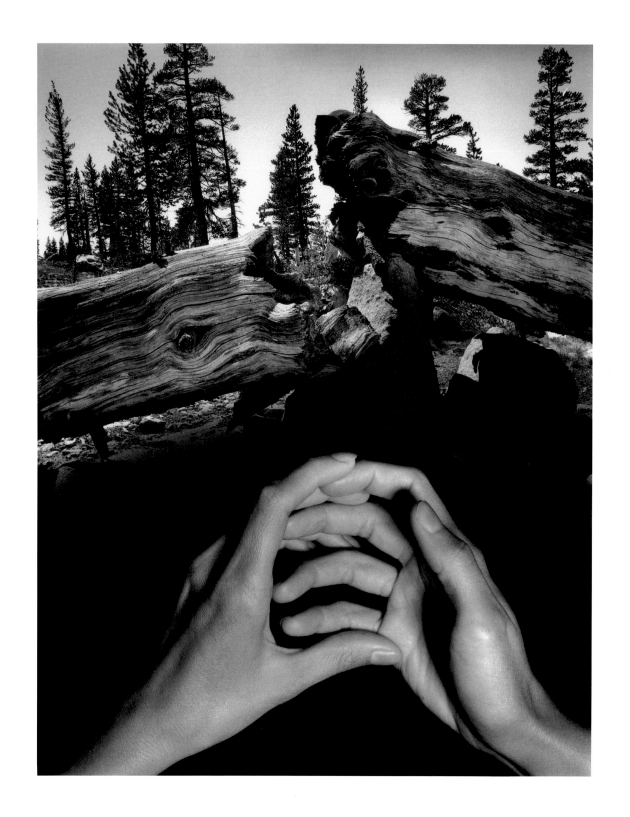

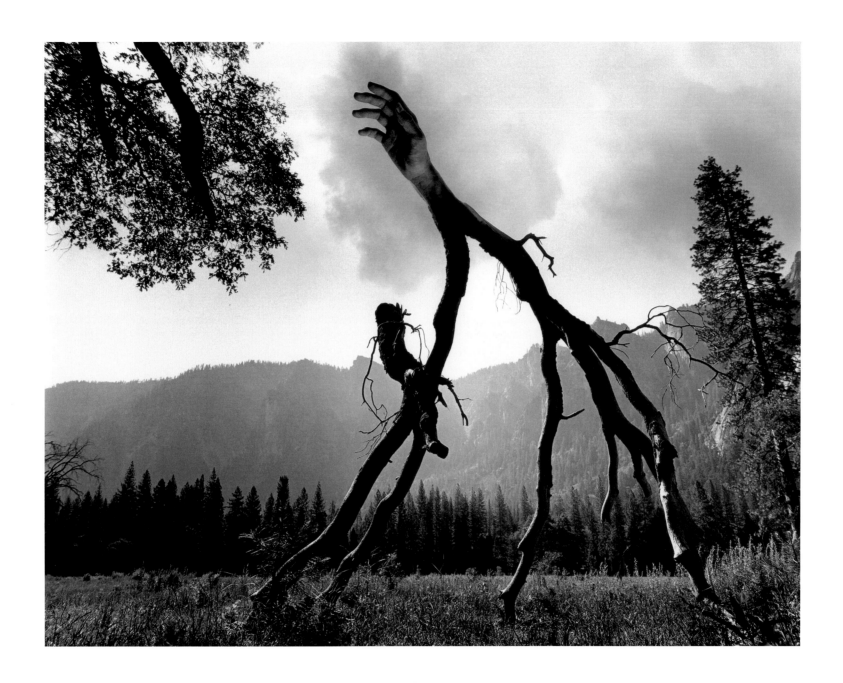

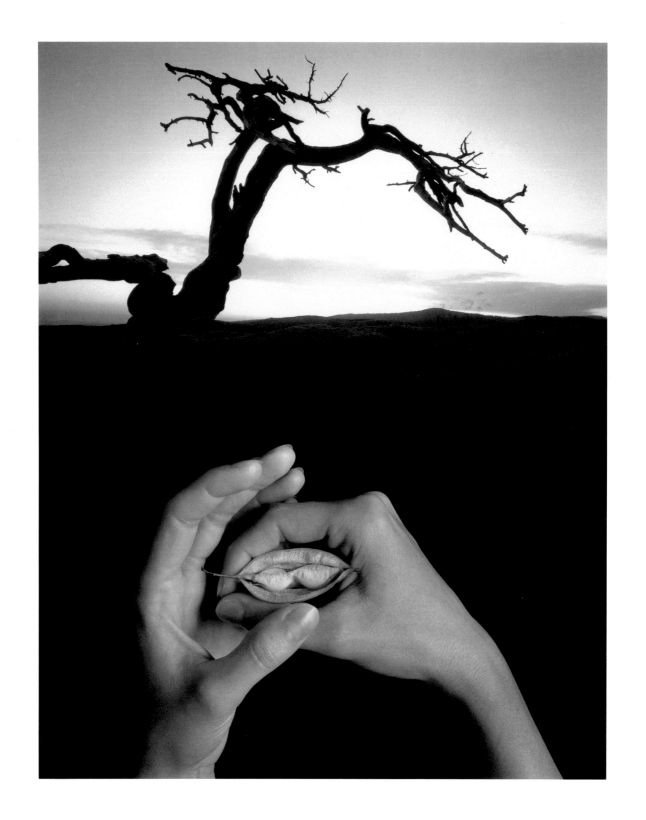

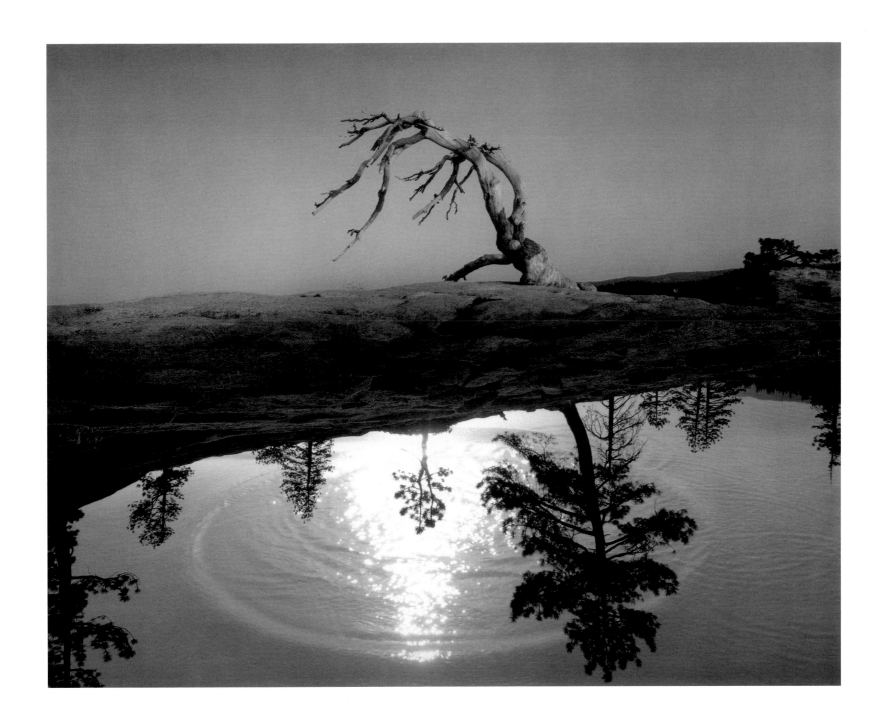

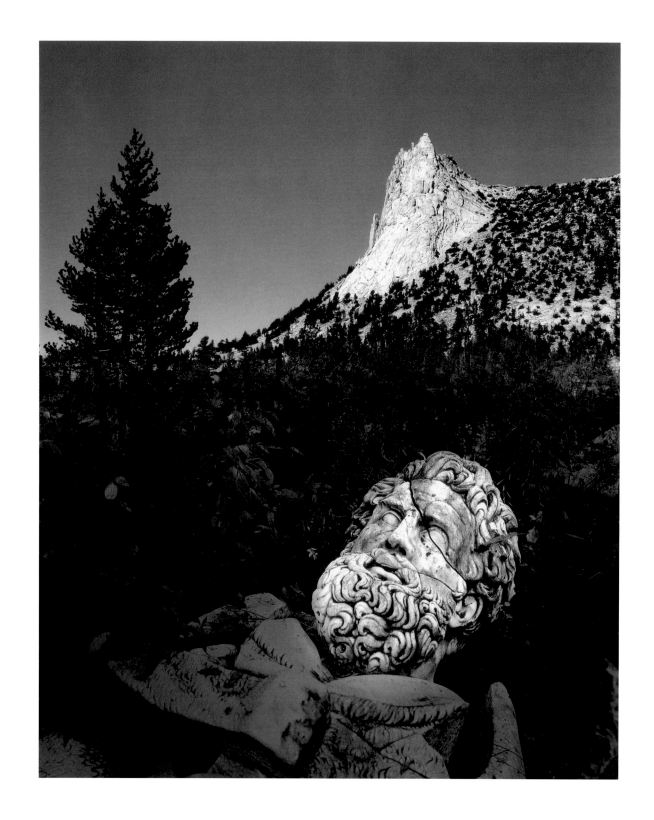

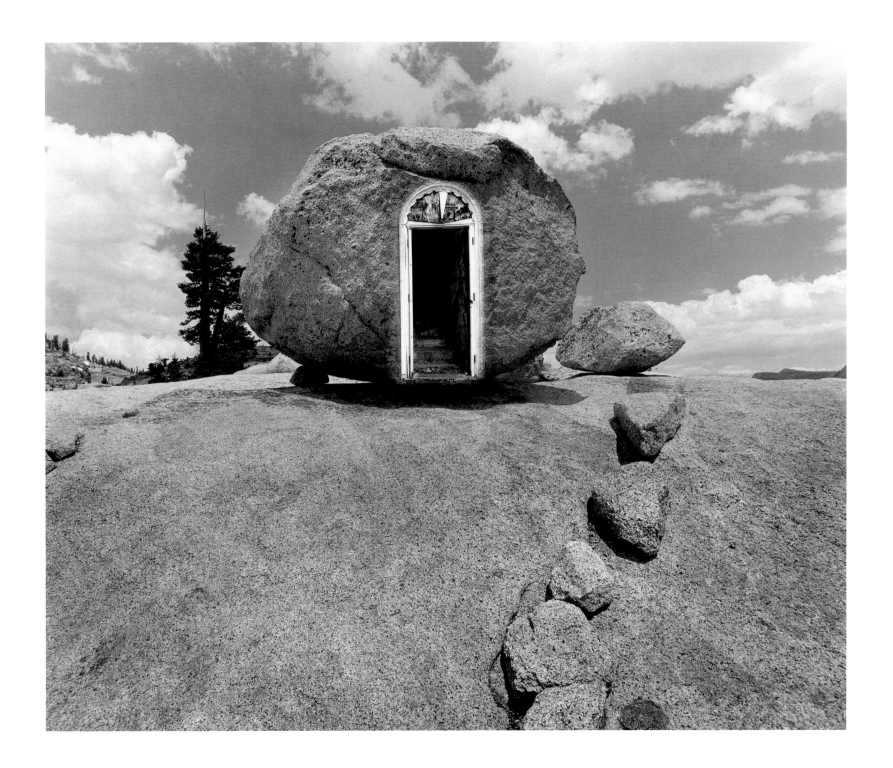

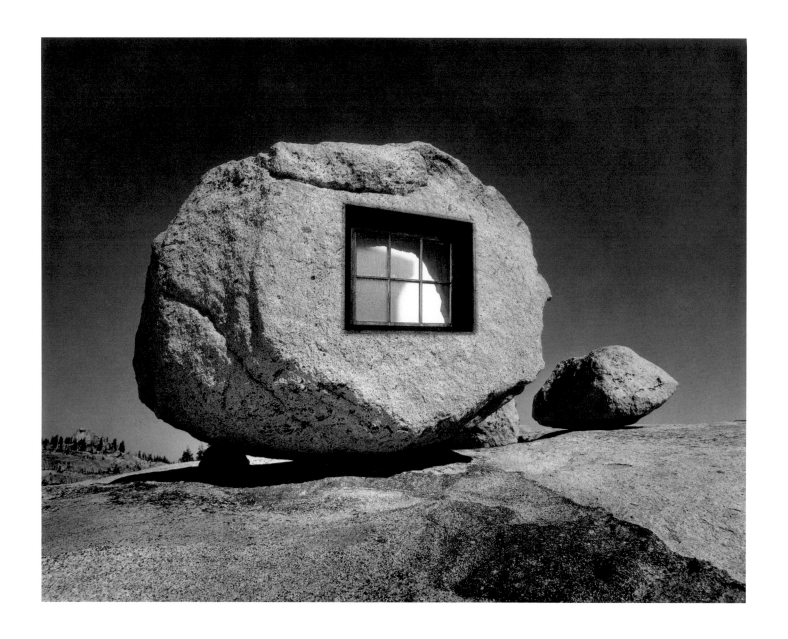

46 / 1990

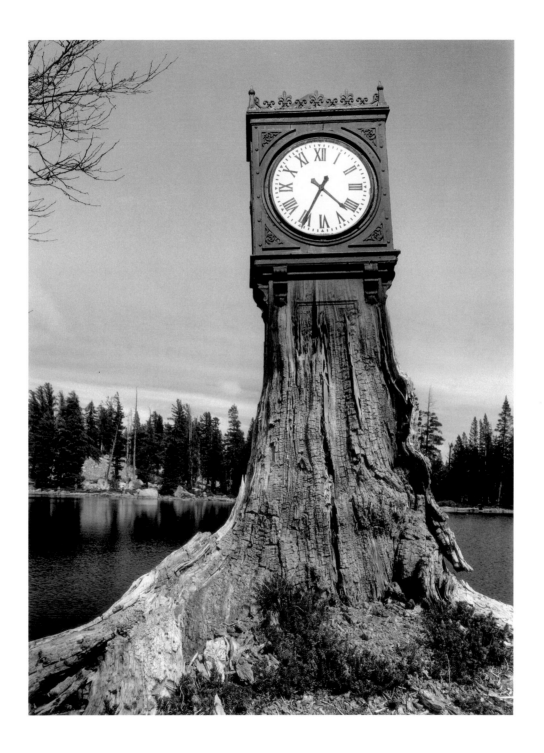

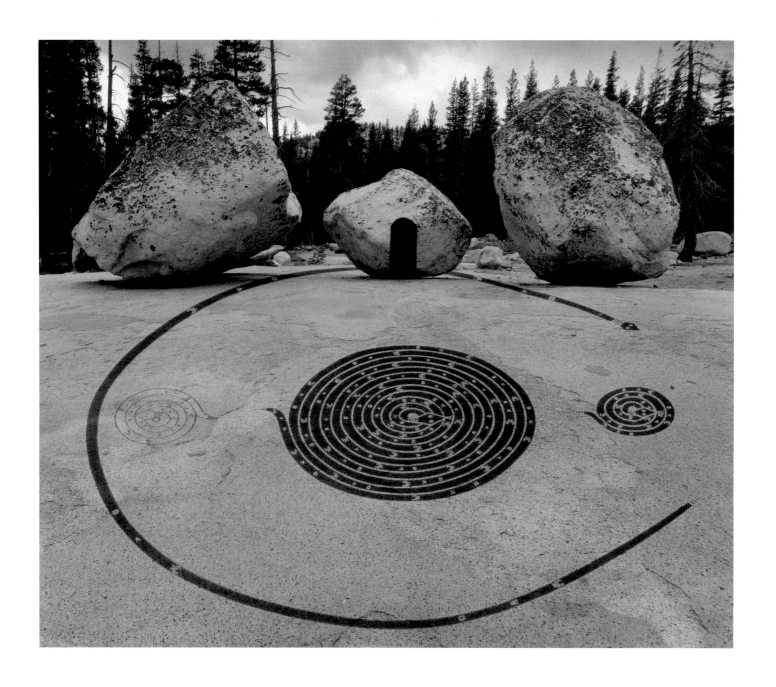

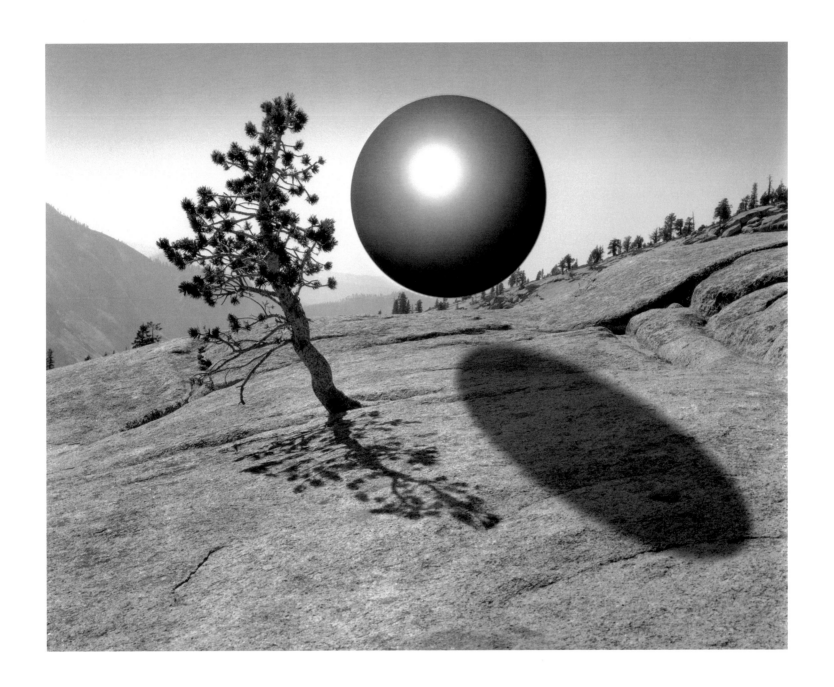

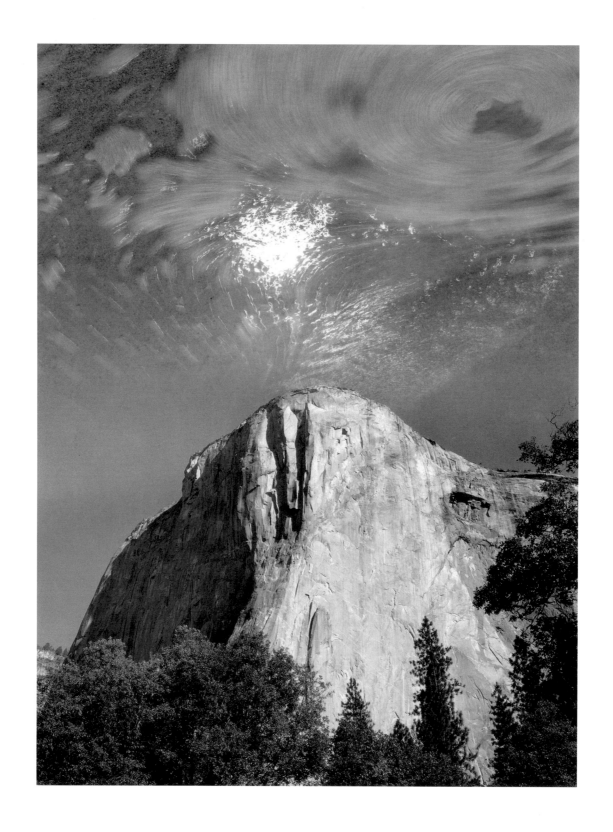

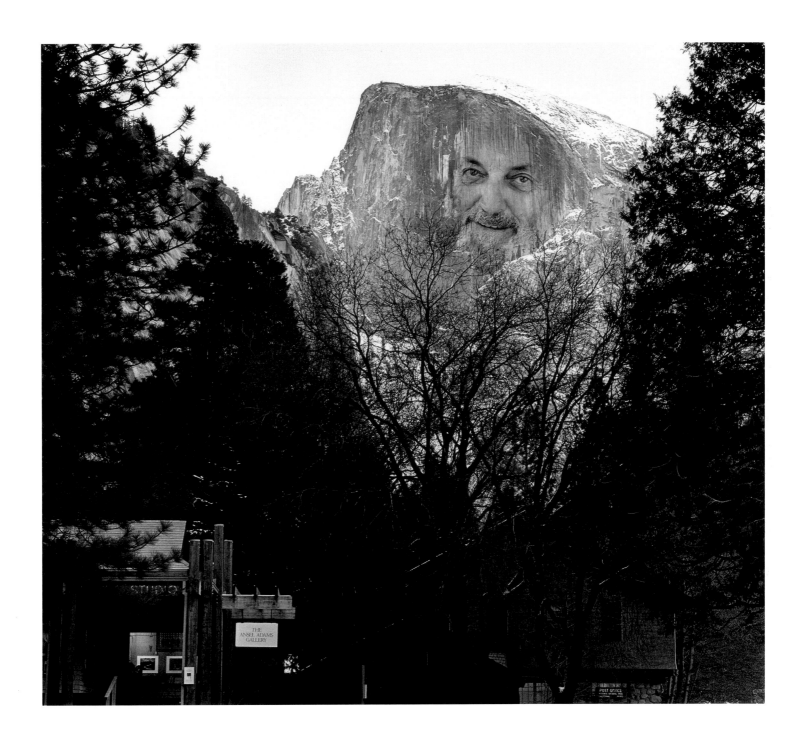

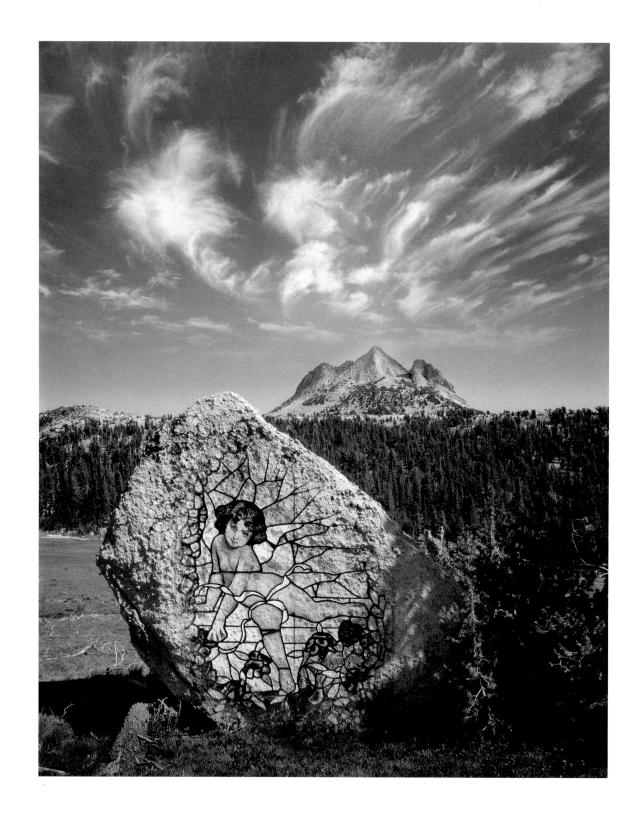

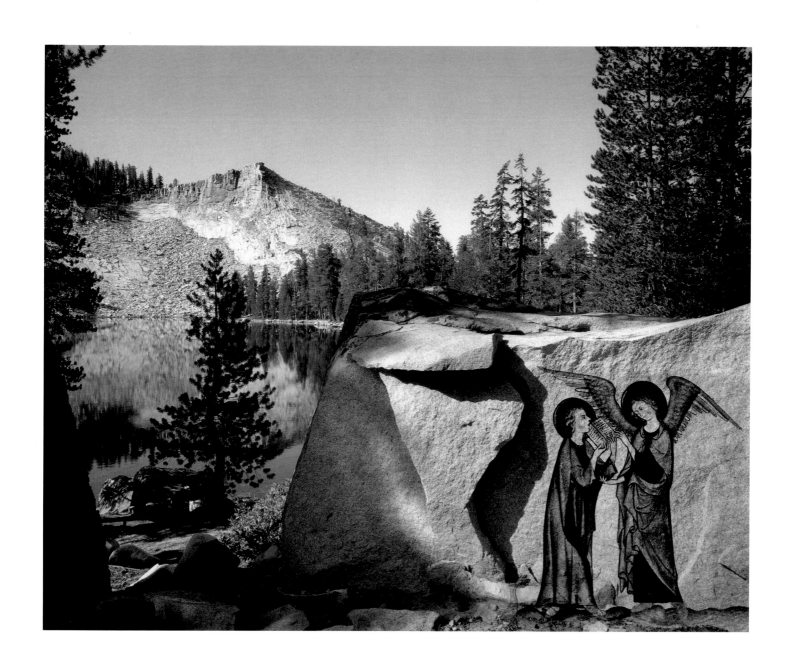

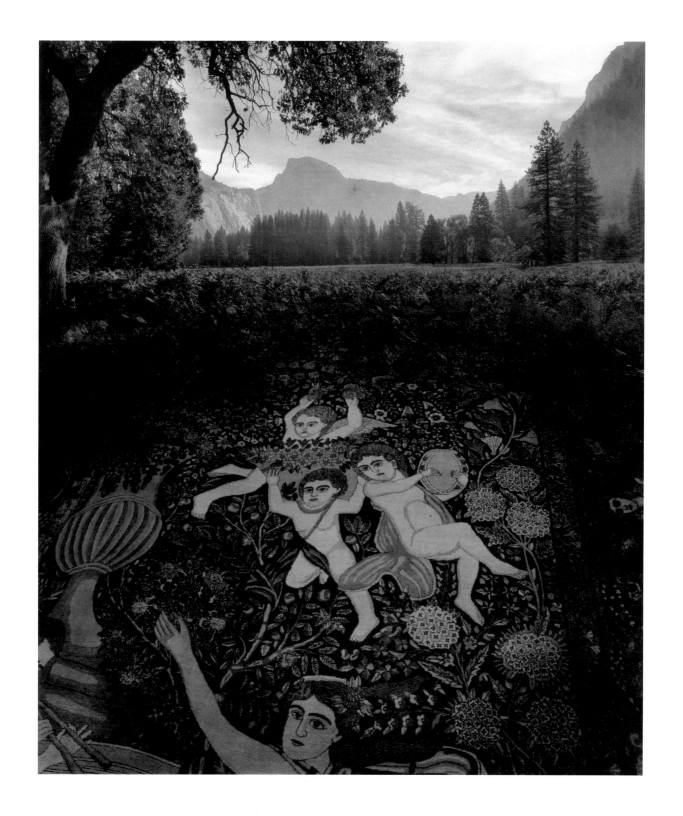

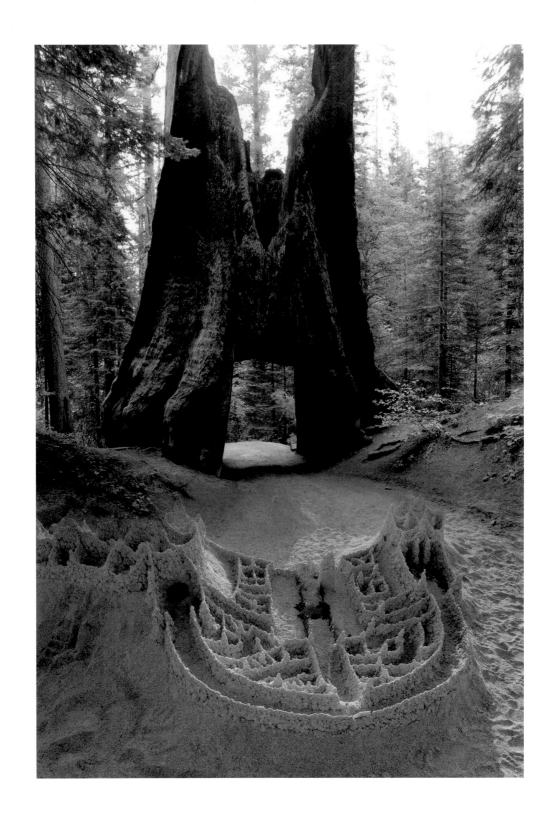

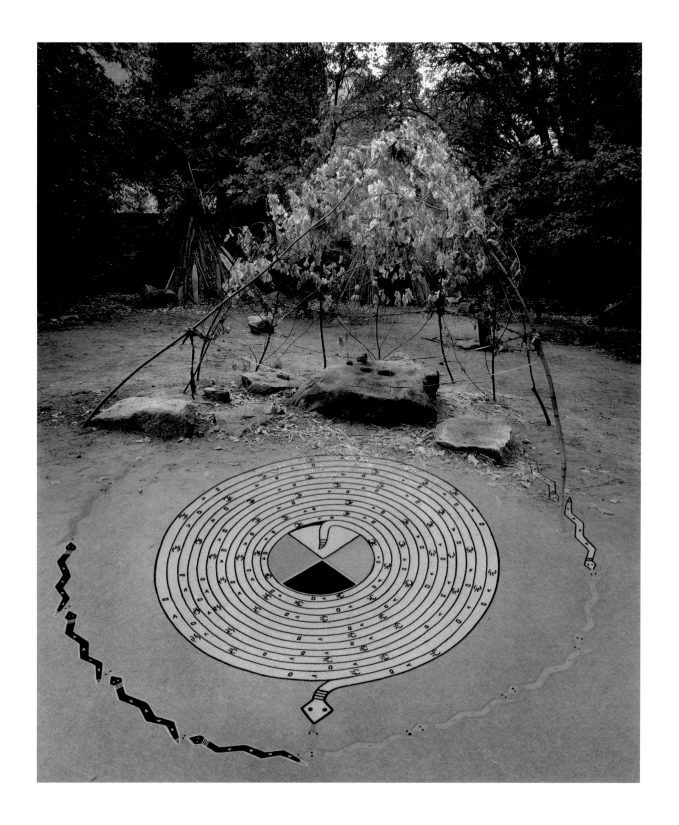

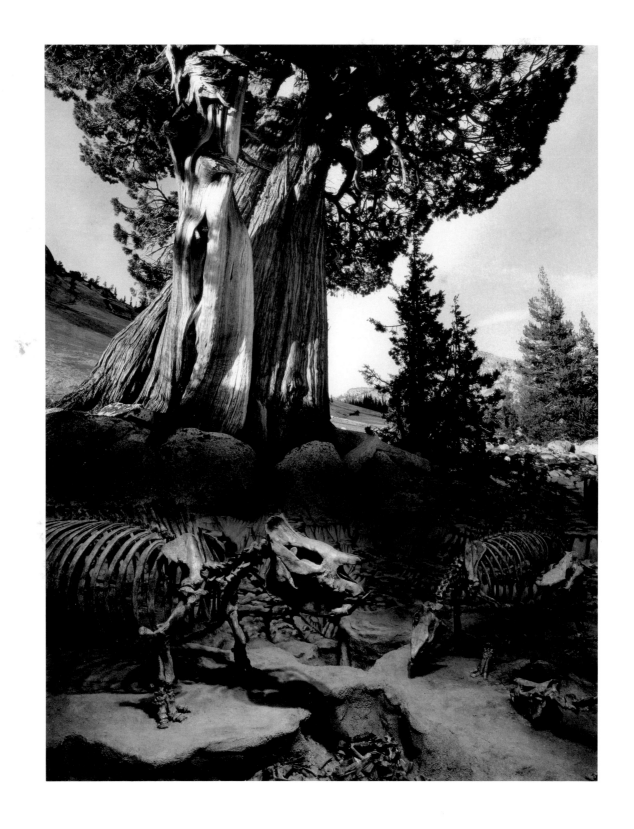

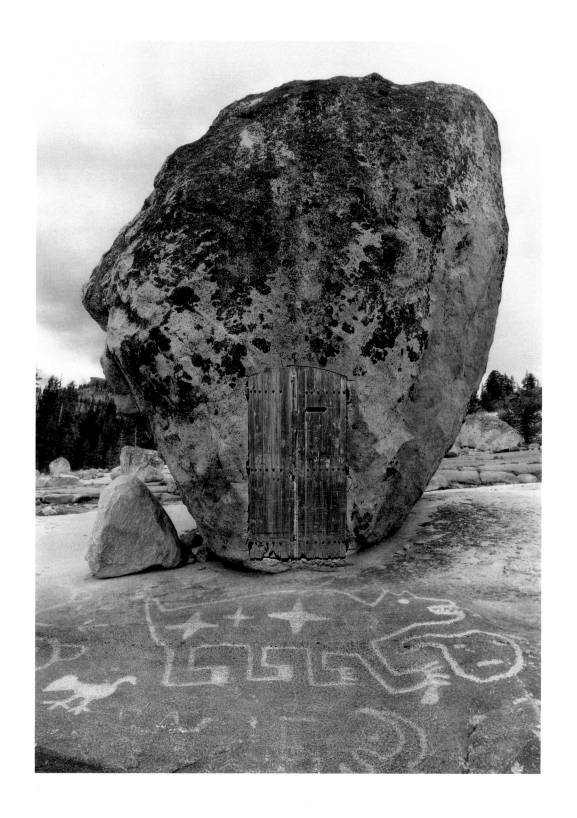

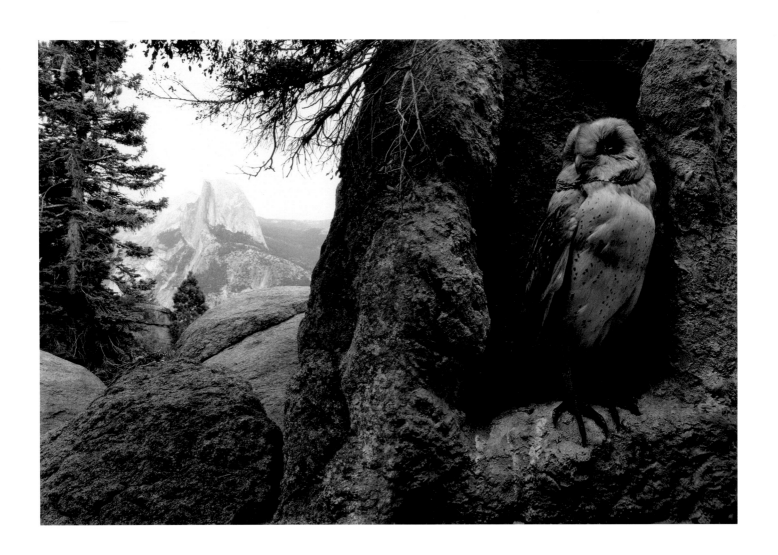

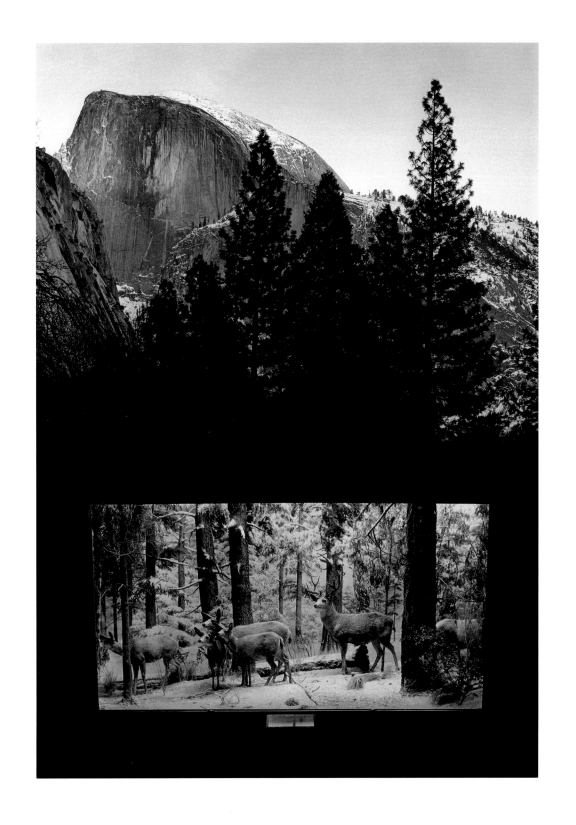

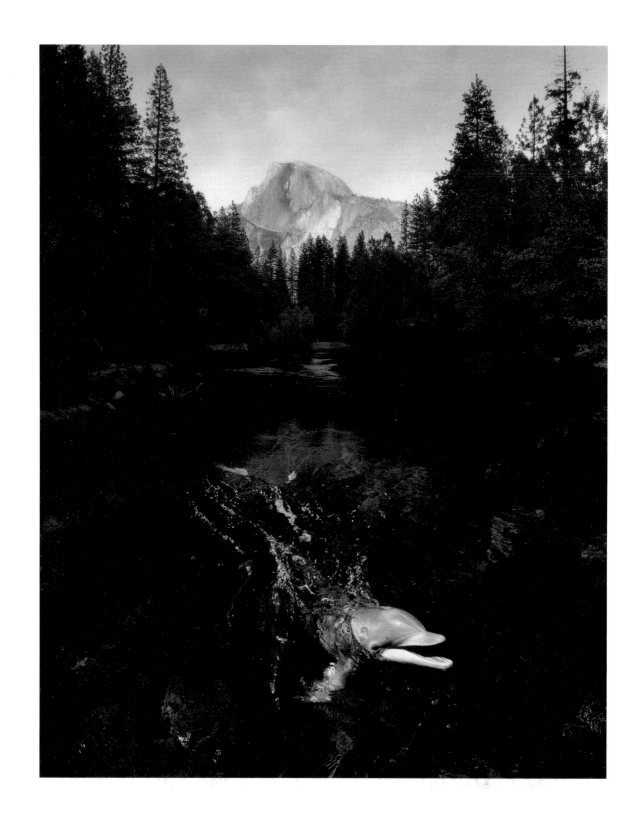

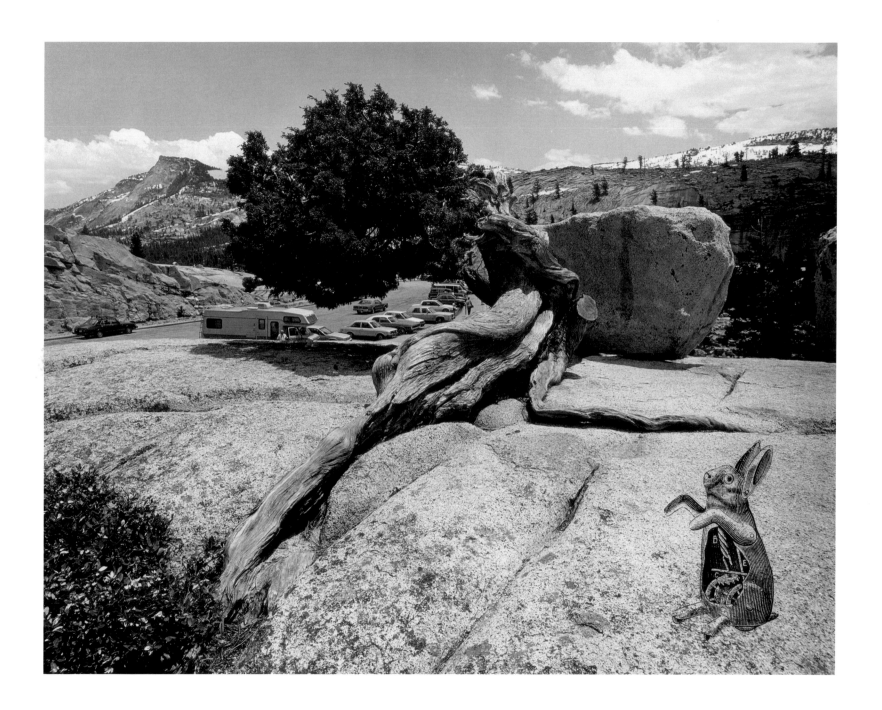

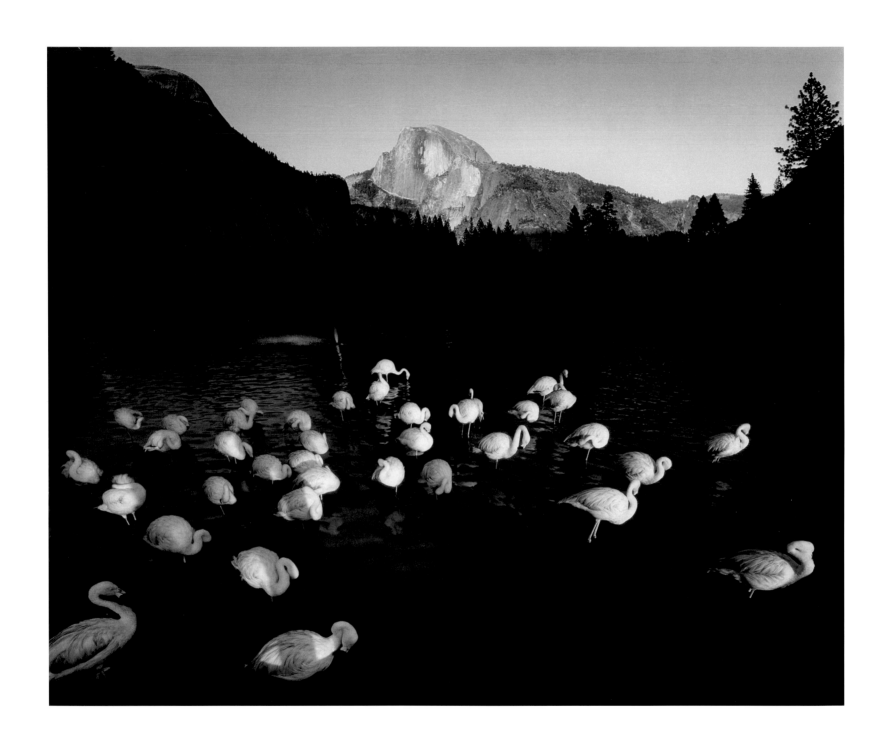

64 / Flamingos Visit Yosemite, 1985

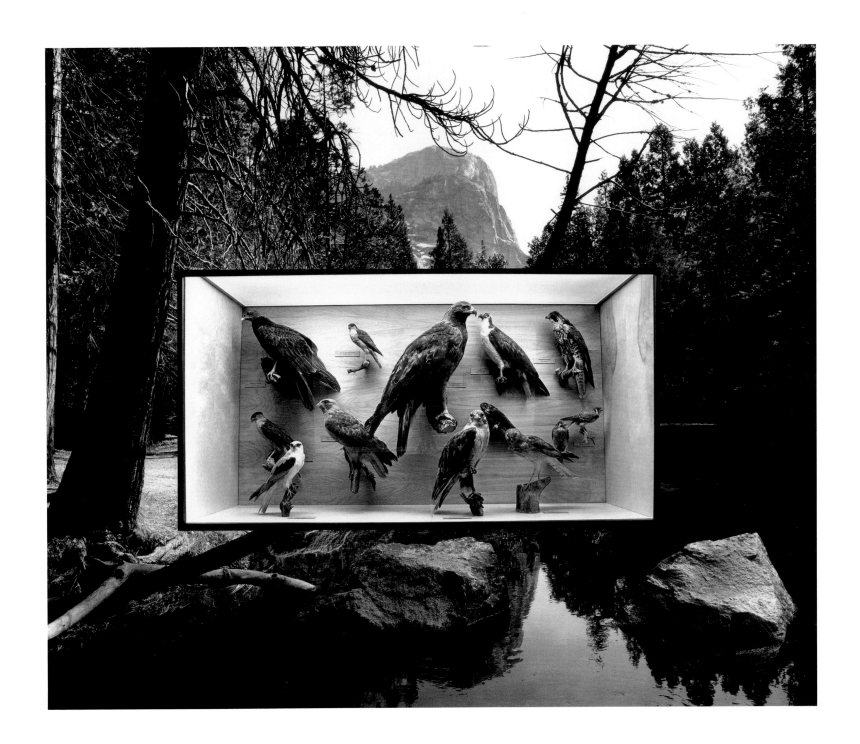

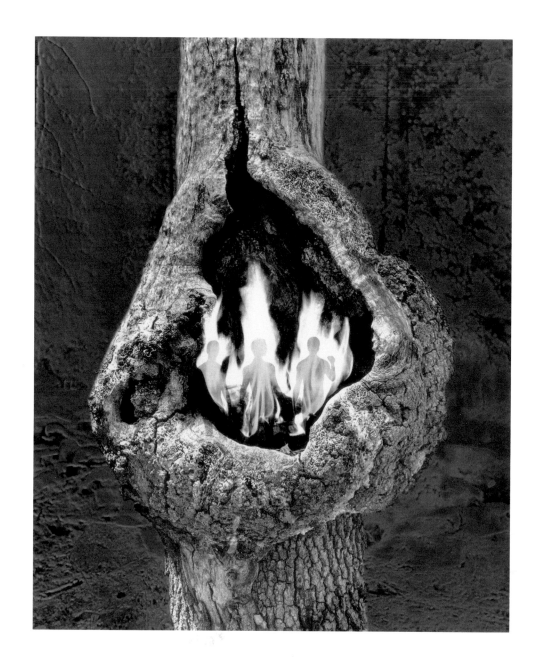

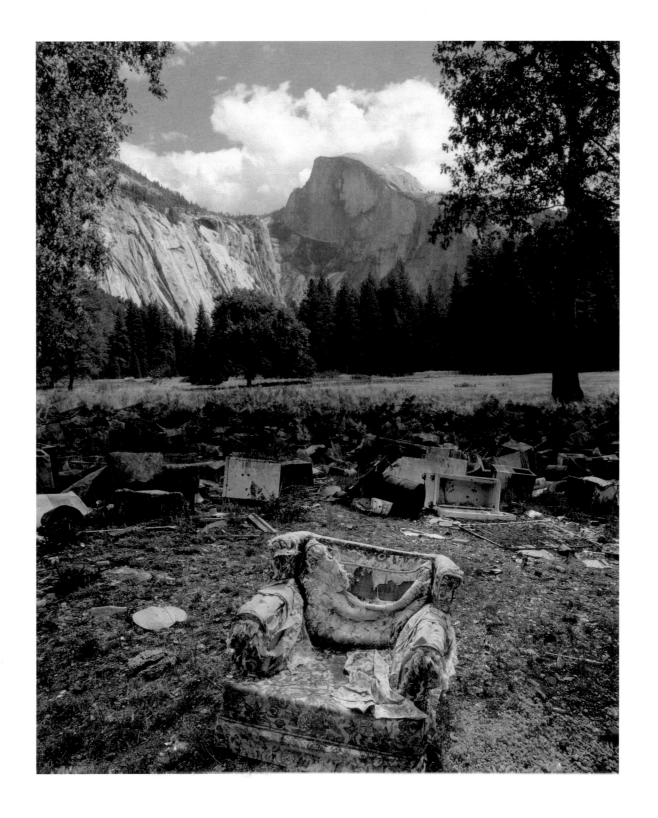

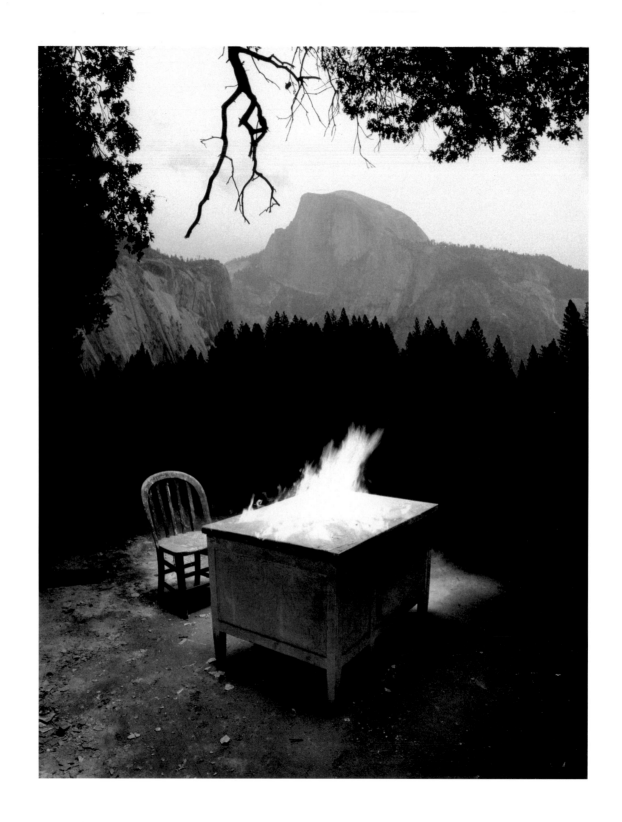